COLOUR

on

PAPER

and

FABRIC

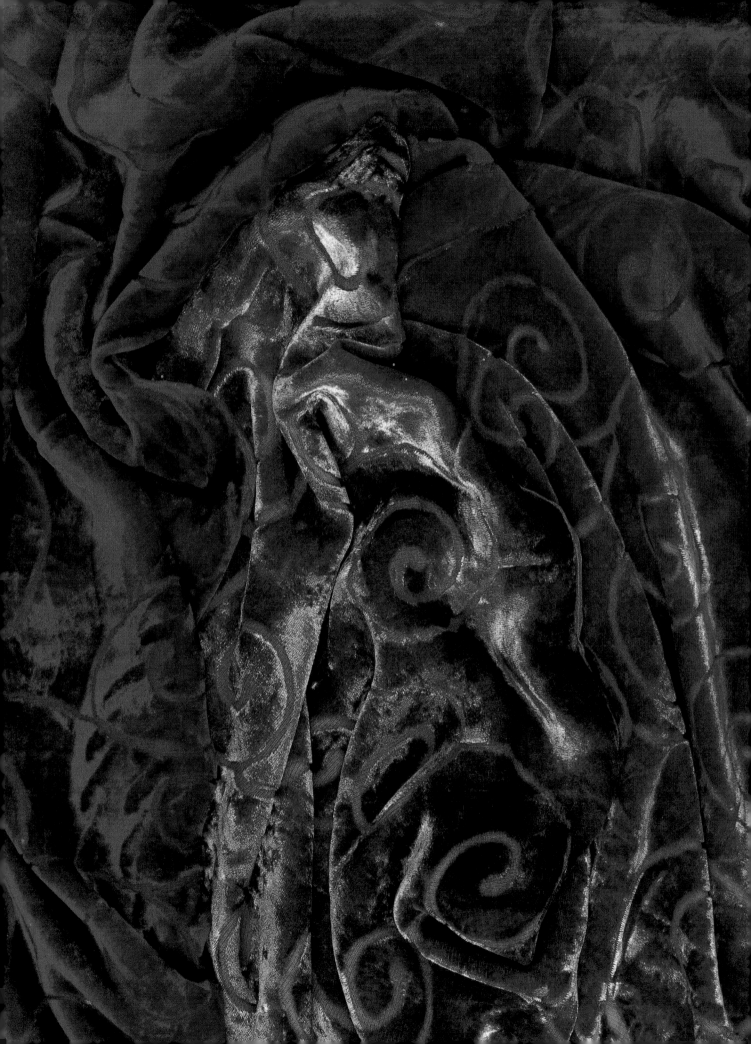

RUTH ISSETT

COLOUR

on

PAPER

and

FABRIC

B.T. BATSFORD LTD. LONDON

ACKNOWLEDGEMENTS

I would like to thank Viv Arthur and Kevin Mead of
Art Van Go for their generosity and enthusiasm,
for sharing their knowledge and encouraging me to
write this book; the staff and students at Ashford
Adult Education Centre with whom I try out new
ideas and my long suffering family – Chas, Lucy,
Adam and Alice – who are always supportive.

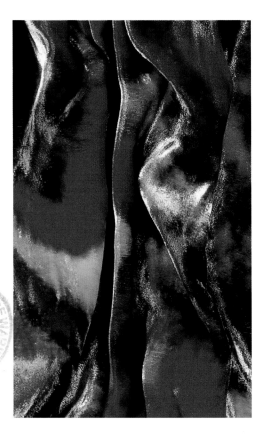

First published in 1998 by
B.T. Batsford Ltd
583 Fulham Road
London SW6 5BY

A catalogue record for this book is available
from the British Library.

ISBN 0 7134 8068 8

Printed in Singapore

Photography by Michael Wicks

Designed by DWN Ltd London

CONTENTS

INTRODUCTION

Designing on paper and applying colour to paper and fabric can be both exciting and terrifying. There is so much to consider, and there is frustration when the ideas in one's head do not come out the same on paper. There is also the fear of getting it 'wrong'.

In many ways learning to use colour, paper and fabric is like being let loose in a well-stocked kitchen for the first time. There are so many flavours, tastes, textures and methods to be considered that one needs to allow time, first to become acquainted with the raw ingredients, and then to discover how to bring out their best qualities. It is difficult to find an opportunity to explore and experiment with many colouring mediums in the way one might experiment with food. However, it is important to try the different mediums to see how they respond and the effects that can be achieved. Approach such experiments lightheartedly but with a sensitive touch, and you will quickly become aware of the quality of each colouring medium and how it reacts on different papers or fabrics. As with cookery, there will be failures but there will also be successes, and you will learn from each.

This book sets out to suggest some simple ways to explore colour, paper and fabric. It has a few recipes to follow to make a finished piece, but essentially it is intended to give, in easy-to-follow terms, instructions and inspiration for beginners and for those more experienced so that you can begin to create your own finished pieces. You will soon find that each material and every technique has a million different applications, each offering the opportunity for creating individual effects.

The enjoyment and excitement of exploring colour, paper and fabric should be paramount, for it is then that the anxiety and frustration will fade as you experience the pleasure of creating a unique piece of decorated paper or fabric to use around your home or to give as a special gift.

Facing page: viscose satin, dyed and painted with a range of Procion colours, block printed and roller printed with gold bronze powders and interference acrylics.

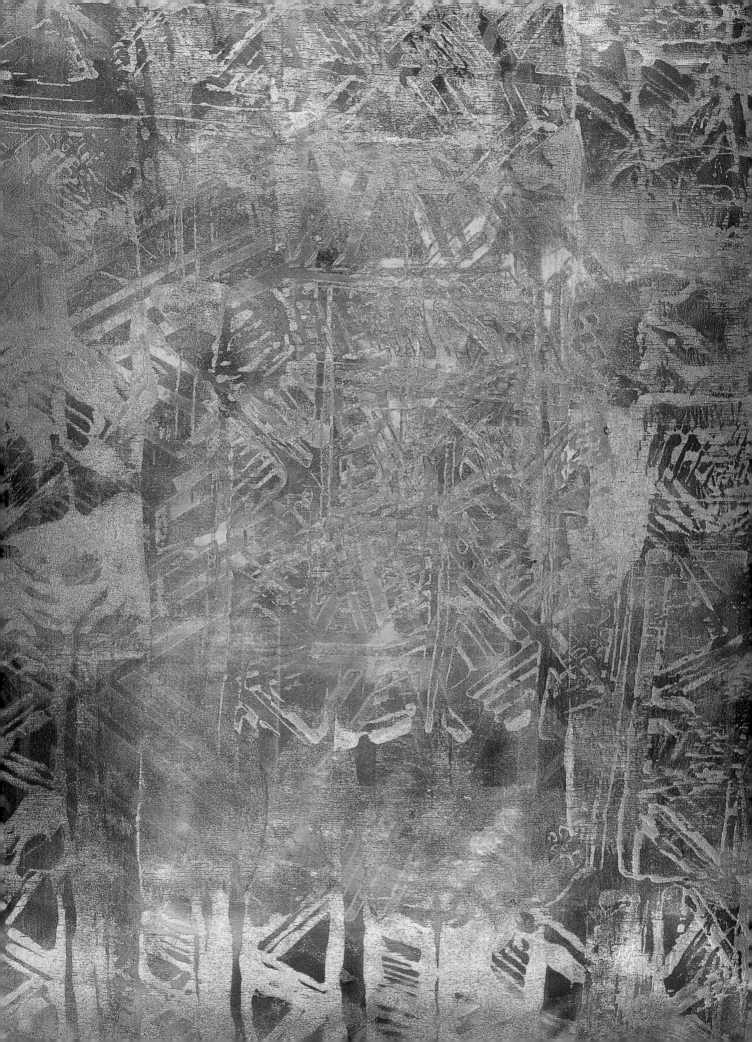

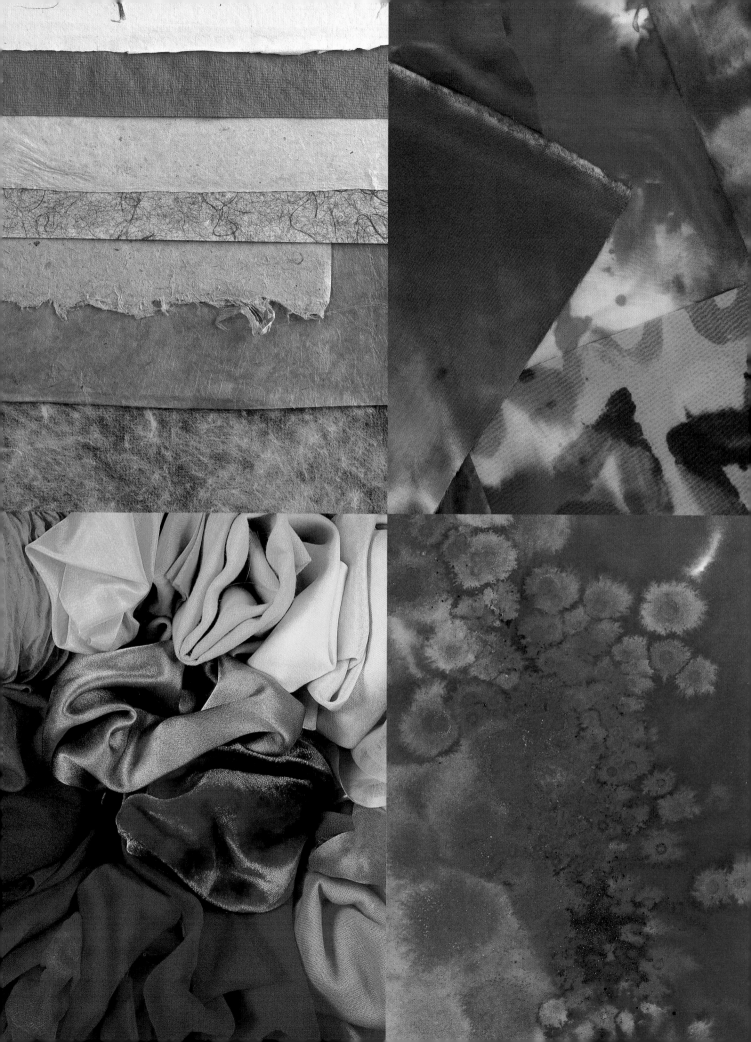

CHAPTER 1

MATERIALS

This chapter outlines the basic materials required to create your own

coloured and patterned paper and fabric. A wide range of different

papers, fabrics, printing, dyeing and colouring mediums is illustrated and explained.

The information is intended to be clear and straightforward so that you can

access the guidance you need quickly and easily.

By the end of this chapter, you will have a better understanding of the

different materials and their potential to colour and decorate paper and fabric.

Your fingers will be itching to start and your mind will be packed

full of colourful ideas!

COLOUR AND DYEING

Mixing colour is important, not only for dyeing but for printing, designing and for generally using in all types of work. It is easy to imagine that it is possible to mix all the colours of the rainbow just by purchasing one yellow, one blue and one red. A few frustrated attempts, producing some rather indifferent coloured samples, might cause one to think again. The problem is that one yellow will not give clear oranges as well as clear greens, just as one red will not give luscious purples and bright oranges, or one blue rich mauves and sharp greens.

It is advisable to begin with at least two of each of the primary colours. For blues choose turquoise and ultramarine. For reds, scarlet and cerise. And for yellows, lemon and golden yellow. These can be arranged logically around a colour circle, creating a gentle transition from one colour hue to the next. By mixing these dyes together, or by over-dyeing one colour upon another, you will achieve a wonderful range of colours.

More subtle colours can be created by mixing colours which are not immediately adjacent to each other in the colour circle. For example, mixing lemon yellow and ultramarine will produce a much softer, slightly muddier green than you might expect. This is because ultramarine contains a small amount of red. Mix cerise and golden yellow in varying quantities to produce a spicy burnt orange, ginger or caramel, depending on the proportions of cerise to golden yellow. And try mixing colours across the colour circle, such as turquoise and scarlet, to produce a lovely range of browns, rusts and rather interesting purples.

When mixing dark colours be careful not to waste quantities of colour, as dark colours tend to saturate lighter ones and become so dark that clarity of colour is lost. Always add dark to light, carefully adding small quantities of the darker colour until you have obtained the shade you require. If you add light to dark you will need large quantities of the lighter colour to counteract the strength of the darker colour and this can be a time consuming and costly exercise.

When dyeing it is often worth while incorporating black and dark brown into your selection of colours. Fabrics that start off being very brash, gaudy and harsh can be toned down by a further immersion in a bucket of either black or dark brown dye. The black tends to be a blue/grey colour whereas the dark brown tends to be rather pink in colour and will therefore warm the colour palette.

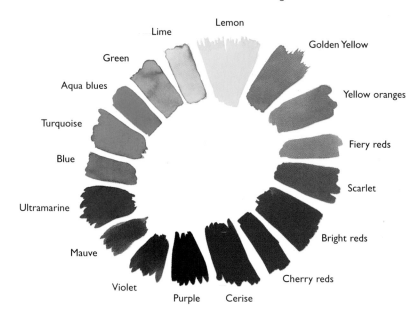

- Lemon
- Lime
- Green
- Aqua blues
- Turquoise
- Blue
- Ultramarine
- Mauve
- Violet
- Purple
- Cerise
- Cherry reds
- Bright reds
- Scarlet
- Fiery reds
- Yellow oranges
- Golden Yellow

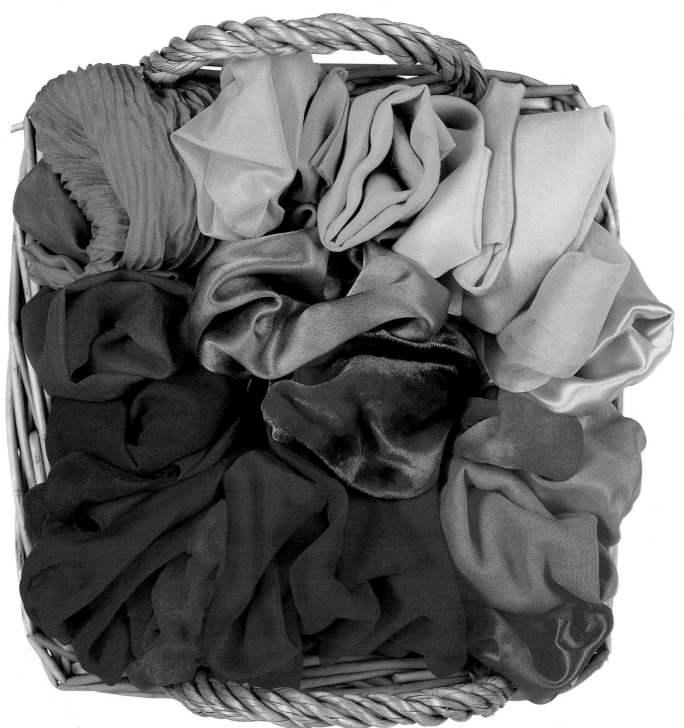

A selection of natural fabrics all dyed or painted using a limited range of Procion dye colours.

DYES

When first learning to colour fabrics, many people confuse dyes and fabric paints. On the whole, fabric paints come ready prepared and mixed, and all you have to do is open the bottle and apply them to the fabric. Once dry, they require fixing, either by heat or with a fixative. Dyes are usually much more fluid. They often have to be mixed from a powder, but once certain chemicals are added they are permanent. The dyes used in this book are Procion dyes, which are cold-water, fibre-reactive dyes. They are available in a limited but intermixable colour range and are designed to be used on 100 per cent natural fibres (i.e. silk, cotton, linen and viscose). Fibre mixtures will produce variable results depending on the individual fibres.

Dyes become permanent on fabric because of a chemical linkage between the fabric, the dye, and the acid and alkaline chemicals added to the dye. Although this sounds complex, you'll find that using cold-water dyes with the recipes given later in the book is very simple, let alone exciting and absorbing.

The following chemicals are necessary to a greater or lesser degree when mixing up Procion dyes for use on fabrics. They are available either from a Procion supplier by mail order or, for washing soda and Calgon, from your local supermarket.

ACIDS

● **Urea** Synthesized from natural gas, urea helps dyestuff dissolve effectively and delays the chemical reaction with the water by absorbing moisture from the atmosphere. It is very beneficial to the setting process, especially with painted fabrics.

● **Common table salt** This helps the dye penetrate the fabric to produce a good colour.

● **Resist salt L** This also helps colour yield, although it is not essential for small quantities of dye.

ALKALINES

● **Washing soda** (Sodium carbonate) – An essential alkaline, creating a chemical reaction with the acids and the dye to fix the dye in the fabric.

● **Soda ash** (Anhydrous sodium carbonate) – An additional alkaline, but not always very readily obtainable. Using it will improve the dye yield.

● **Calgon** (Sodium hexame taphosphate) – A water softener which helps neutralize water. Hard water can sometimes affect a dye and cause coagulation.

HEALTH AND SAFETY WARNING

Dye powders are very fine and may produce allergic responses in some people, especially in the respiratory tract. Always heed the following points when mixing dyes:

● Mix in water and wear a mask, rubber gloves and protective clothing.

● Use soap and water to remove splashes from the skin, not bleach or potassium mangate which might break down the dyes into hazardous substances.

● Equipment used for dyeing should be used solely for that purpose.

● Never eat, drink or smoke in a dyeing area.

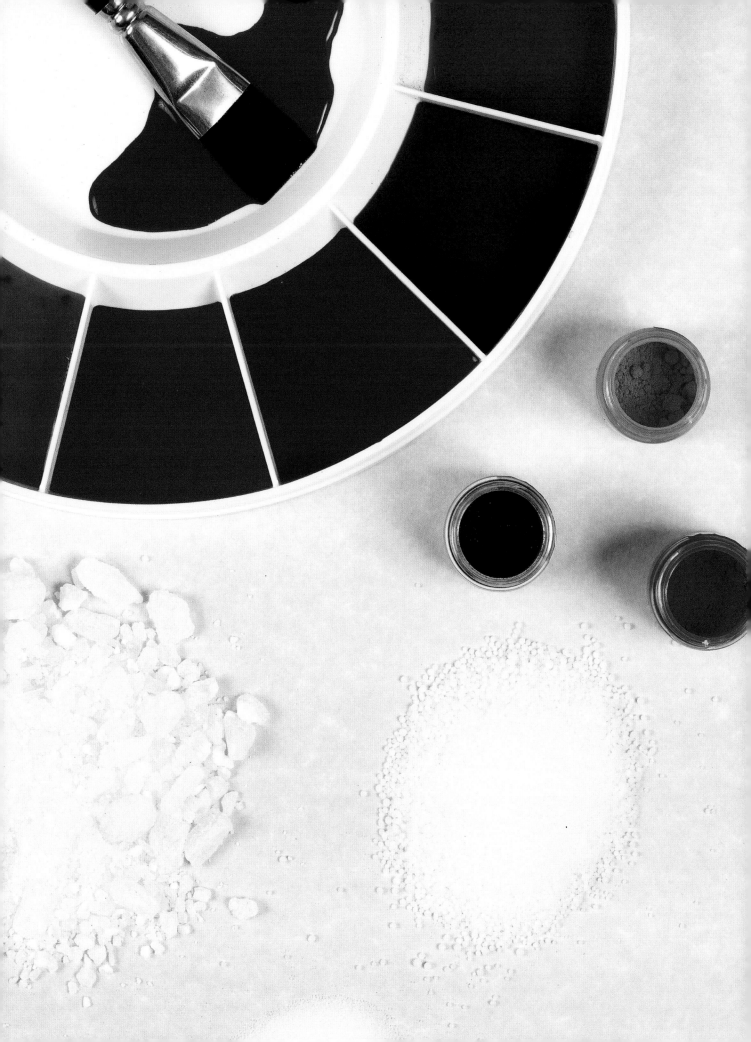

PAPERS

Papers are manufactured for many different purposes: to be absorbent, to absorb water but to stay flat, to protect items, to add strength, or even just to be decorative. You are probably familiar with cartridge paper, tissue paper, and other common household papers, but papers are available in a huge variety of different weights and grades. For the purposes of this book, papers will be evaluated for their qualities when dyed and printed on, and for how variation in their qualities can be used to your advantage when using them in design work.

To begin with I suggest that you use readily available papers, such as tissue, good quality cartridge and, perhaps, brown wrapping paper. Many ready-coloured papers (e.g. sugar paper and papers manufactured for children) are made from recycled pulp and are often very absorbent. Dyed, inked effects on these papers can be disappointing and rather muddy. However, once you add dye or ink to a good quality cartridge paper, you will begin to produce very rewarding results, with fine clarity of colour.

When using some of the printing methods with acrylics and bronze powders, you will find that different weights of paper will respond differently according to their strength and your pressure when printing. For instance, tissue paper may tear if pressed too hard onto a surface that has been coloured with acrylic. But it can produce a subtle print if gently placed on top of an inked block and lightly patted.

Once you feel confident with the more common papers, you can try some of the ever-increasing range of handmade Asian and South American papers. Some of these are very delicate and light, others quite textural because of the fibres that are used to make them. Indian rag papers, for example, are made from cotton, wool, tea, or straw, and the finished surfaces show signs of these materials. In the manufacturing process, papers are finished in a variety of ways, and each will produce different qualities and surface patterns on your work. The finish will affect the inking, the print quality, and the way in which different drawing equipment will respond when used directly on the surface.

The papers illustrated show some of the types that are readily available. Most are supplied in natural colours, although there is an increasing number of interesting coloured papers, such as Tibetan bark paper, which comes in a variety of different colourways, each of a mottled nature. Commercially produced coloured papers or light card come in a reasonable range of colours, especially those made by Canford and Canson. However, it is difficult to obtain an extensive range of strong, brightly coloured papers, so this must be remedied by painting or dyeing your own. There follows a description of some of the papers you may use:

- **Brown** Associated with parcel wrapping, this paper can vary from being almost translucent to strong and thick. It responds well to the application of different colouring mediums, though these will obviously be affected by the paper's base colour.
- **Cartridge** Universally available, usually in white or cream, it comes in different weights or thicknesses.
- **Indian rag papers** Handmade using long-fibred, handspun cotton rags, this strong paper

has surface sizing and deckle edges. Southern Indian rag fibre papers are hand made from cotton rag and tropical plant fibres. They include:

Bagasse Made from sugar-cane fibre.

Banana Made from banana-leaf fibre.

Gunny This is recycled jute sacking.

Straw A smooth paper, with small pieces of straw incorporated into its surface.

Tea This paper has a regular texture, as if it has been pressed onto a woven surface. Fine tea leaves give the paper a speckled pattern.

Wool A smooth paper with fine wool fibres embedded into its surface. These produce a mottled pattern.

- **Indian silk** A soft cotton paper with long silk fibres laid into it.

- **Lokta** Made from the bark of the lokta plant, this translucent paper comes in shades varying from cream to pale brown. The long plant fibres produce a strong paper which wrinkles when inked, the extent of the wrinkling depending on the thickness of the fibres.

- **Mulberry tissue** Made from the bark of the mulberry tree, it is lightweight and is traditionally used for layering and for waxing Thai umbrellas.

- **Tissue** Readily available, lightweight, smooth and delicate, it tends to break up if it gets too wet, but is useful to use in layers. It becomes transparent when varnished.

- **Watercolour** This paper is available in a range of weights, usually indicated in grams or pounds. There is also a number of different finishes: Rough, Not, and Hot Pressed (HP).

Right: A selection of papers that is readily available: cartridge, watercolour paper, brown paper, tissue paper.

Overleaf: a selection of different Asian handmade papers.

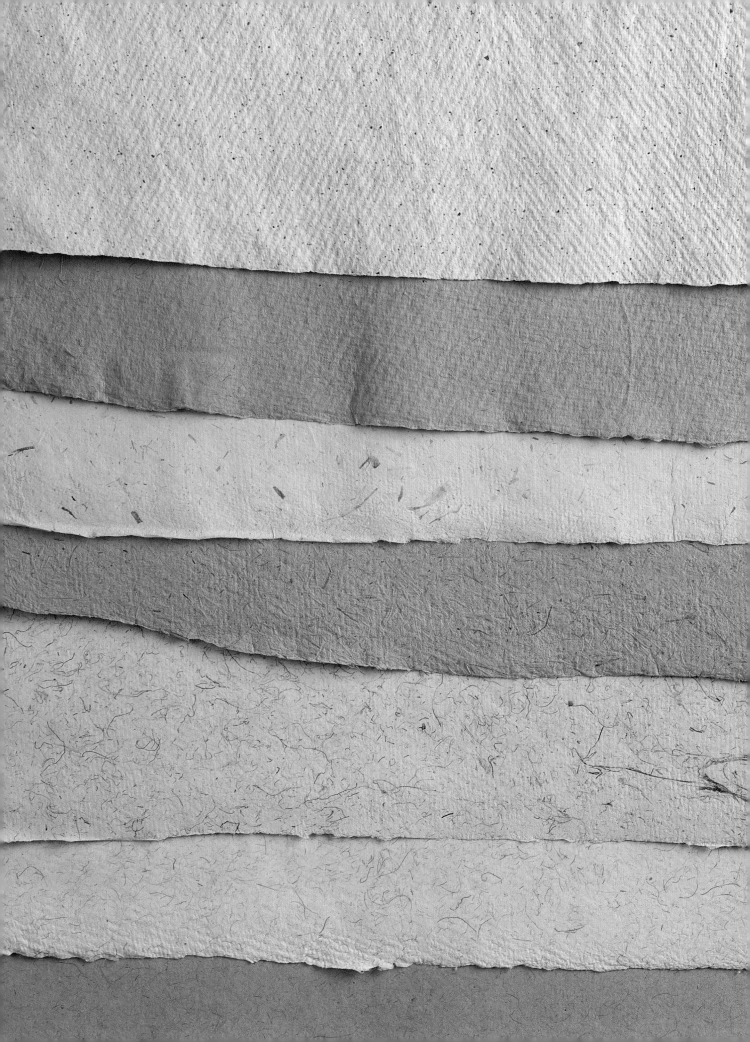

Carrier bags made from papers coloured with a combination of inking and printing. These papers are often produced incidentally when removing the excess colour from the surface of fabric.

FABRICS

Choosing a fabric can often be a complicated and frustrating exercise. A little carefully considered research before you go shopping or start dyeing or printing could save you many fruitless hours!

There is an enormous, complex and ever-changing range of fabrics available. For instance, cotton is available as cotton sheeting, cotton poplin, cotton voile, cotton muslin, cotton organdie, and in many other variations. Here they have been listed in order of thickness, which is determined by the thickness of the spun thread when woven. The spacing between each of the threads creates the fabric's density or transparency. This is apparent when comparing heavy cotton sheeting, which has closely woven, thick threads, to cotton muslin, which has loosely woven fine threads. The quality of the spun thread is also relevant: the finer the thread, the better the colour absorbency during dyeing. So, a fine, pure cotton poplin, which may have one hundred threads to the inch – and thus one hundred threads to be dyed per inch – will obviously take on a much more intense colour than will a loose-woven cotton muslin which may have only twenty threads to the inch.

Remember that for dyeing or painting on concentrated dye (see page 52), the nature of your fabric, be it closely woven, or loosely woven with thick or thin threads, will affect the results of your painting and dyeing. The actual weave of the fabric will also affect the result, dictating the absorbency of dye into the fabric and the acceptance of printing colours. Contrasts will be found with piled materials such as velvets, rough slub textures such as silk dupion and silk noil, or shiny fabrics such as silk satin or satin viscose. Illustrated on page 25 are different fabrics dyed in the same colour dye. Note the colour variation despite the fact that all the fabrics were put into the same dye bucket. Illustrated on page 24 are cottons of different weaves, also dyed in the same colour. These fabrics vary in colour because of the density of weave, the fineness of the spin of the thread, and the finish of the thread.

For dyeing with Procion dyes, choose natural fibres – those made mainly from plants – such as cotton, linen, viscose (made from cellulose which comes from trees) and silk. These come in a range of different weaves and finishes as well as mixtures of more than one fibre. If you want to use a mixture (e.g. cotton/polyester), remember that polyester will not dye with fibre-reactive (cold-water) dyes. This can produce an attractive tinted colour.

Most of the printing colours available can be used on natural, man-made or synthetic fabrics, including pre-coloured fabrics or grounds, so they allow you a wide choice of materials. However, the printing mediums will change the quality of the original fabric (although this is inevitable when you consider that you are applying a layer of colour, held in a binder, to your fabric). As you become more experienced, you will be able to control these effects, and be able to manage the density of the printing medium. Fabrics you will probably start with are:

● **Cotton** Produced from the cotton plant, it dyes well, although because of the fibre's nature the absorption is slow. Also, as the fibres are matt, dyed colours are less vibrant than on silk. However, some fine, close-woven cottons can produce exceptionally intense colours.

Facing page: cotton poplin, muslin, cotton sheeting, cotton calico, silk habutai, viscose satin and linen are all white fabrics suitable for dyeing and a selection is shown here.

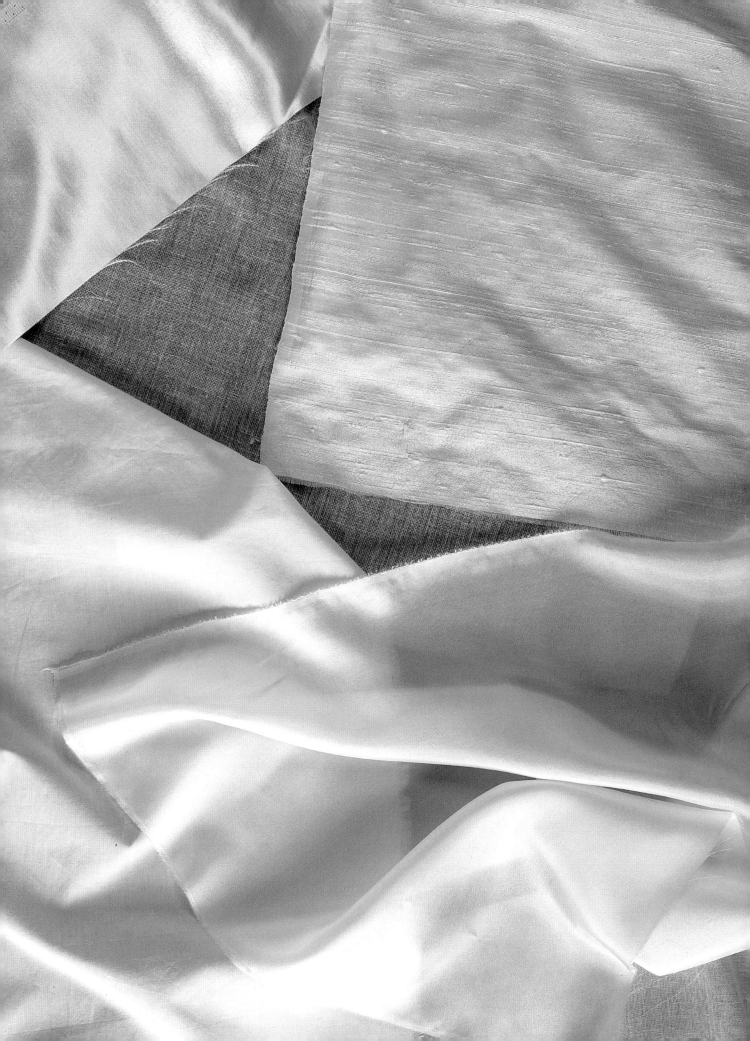

- **Linen** Made from flax, which is a cellulose fibre, linen is expensive to produce, but dyes well.
- **Silk** Made from the thread of the silkworm, the threads are spun in a variety of weights, from fine to thick as well as slubby. Fabrics are gossamer fine to soft and substantial. All dye well, often producing wonderful glowing colours, especially on the fine, shiny threads.
- **Viscose** This is made from regenerated cellulose, which is wood pulp or cotton waste. It is not always easily available but is often used in mixtures. Available from specialist firms, it is excellent for dyeing as it absorbs dye very readily.

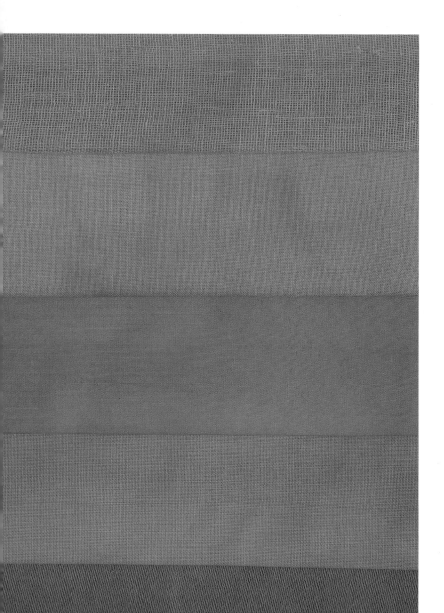

TIPS

- Always prewash a fabric to remove any dressing or finish.

- When dyeing with fibre-reactive (cold-water) dyes choose natural fibres, select for thickness of fibre and density of weave and remember that the colour will vary from fibre to fibre.

- Any fibre is suitable for printing, including a mixture of fibres in one cloth, although if the fabric is highly textured it may affect print adhesion.
- Use coloured grounds, including black, to produce varied results.

Left: cotton calico, cotton sheeting, cotton poplin, cotton mull, cotton muslin, all dyed in the same Procion dye to show how the colour varies depending on the weave and the fineness of the fibres.

Facing page: cotton calico, cotton sheeting, cotton poplin, cotton voile, linen, viscose satin and silk habutai all dyed in the same Procion dye colour.

Next spread: collection of dyed and painted silk velvet scarves painted using the thin dye recipe.

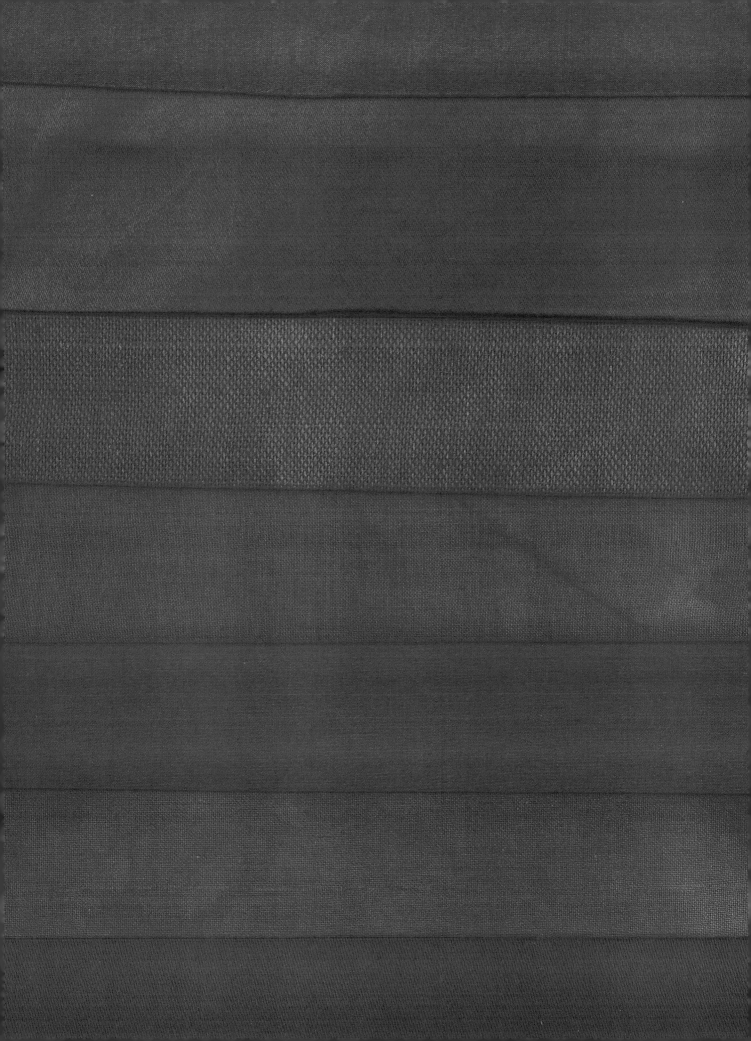

INKS

Facing page (above left): ultramarine Brusho powder sprinkled onto wet cartridge paper.

Facing page (above right): emerald, ultramarine and purple Brusho powder sprinkled onto wet watercolour paper.

Below: Brusho powdered inks and liquid for use on papers.

Inks are transparent colours which are used by many artists and designers. Commercially produced inks come in a range of different types (e.g. waterproof, water soluble, and liquid watercolour, as well as pearlized and fluorescent), and they can be a wonderful resource to 'layer up' colour to give greater depth and strength of colour in your artwork or designs. For textile artists this can complement the techniques used when dyeing and over-dyeing fabric.

creates all kinds of glistening, coloured and patterned surfaces. Inks used in this book are either Brusho inks or Procion dyes.

BRUSHO INKS

These come in powder form in 24 different colours, and one pot will make up 570 ml (1 pt) of ink. However, it is advisable to make up only small amounts at a time by mixing them with water in a palette. The colours are very rich and strong, but pale tints can be created by adding more water. Brusho was designed for use by children and is therefore extremely safe.

Although they can be used on fabric, Brusho inks are not permanent and do tend to fade (as they do on paper when exposed to light for a length of time). However, for experimental work they are an invaluable, cheap source of colour.

PROCION DYES

These come in powder form, and although they are designed as a fabric dye they can be used as an excellent, strongly coloured ink when mixed with water. When mixing to use on paper there is no need to add the chemicals required for fabric dyeing as they will pigment the paper pulps. As mentioned above, it is quite possible to use excess dye – left over from mixing for dye painting – even though they contain chemicals, as the chemicals seem not to affect the papers or the effects they create. However, diluted dyes left over from bucket solutions are not recommended for paper dyeing as they contain too great a quantity of water and therefore appear very weak and pallid. As dyes are chemicals and can occasionally cause irritations, remember to wear rubber gloves and a mask when mixing them.

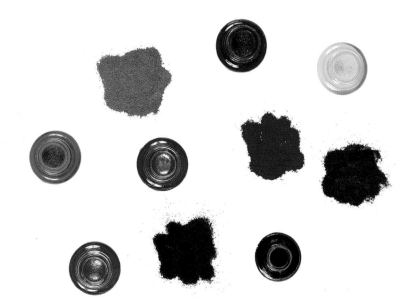

Facing page (below left): ultramarine Brusho ink applied to dry cartridge paper, scattered with rock salt which absorbs the ink and creates a mottled pattern.

Facing page (below right): gamboge, orange and blue Brusho ink painted onto dry watercolour paper.

When making up strong mixtures of dye for fabric, there are sometimes dyes left over, which can become too unstable to use on fabric. Don't waste these wonderful colours; they can be applied like inks to all types of paper, to create coloured grounds which can be enhanced later. Furthermore, the addition of dye or inks to papers that have been printed with acrylic or bronze powders, or drawn into with Markal Paintstiks,

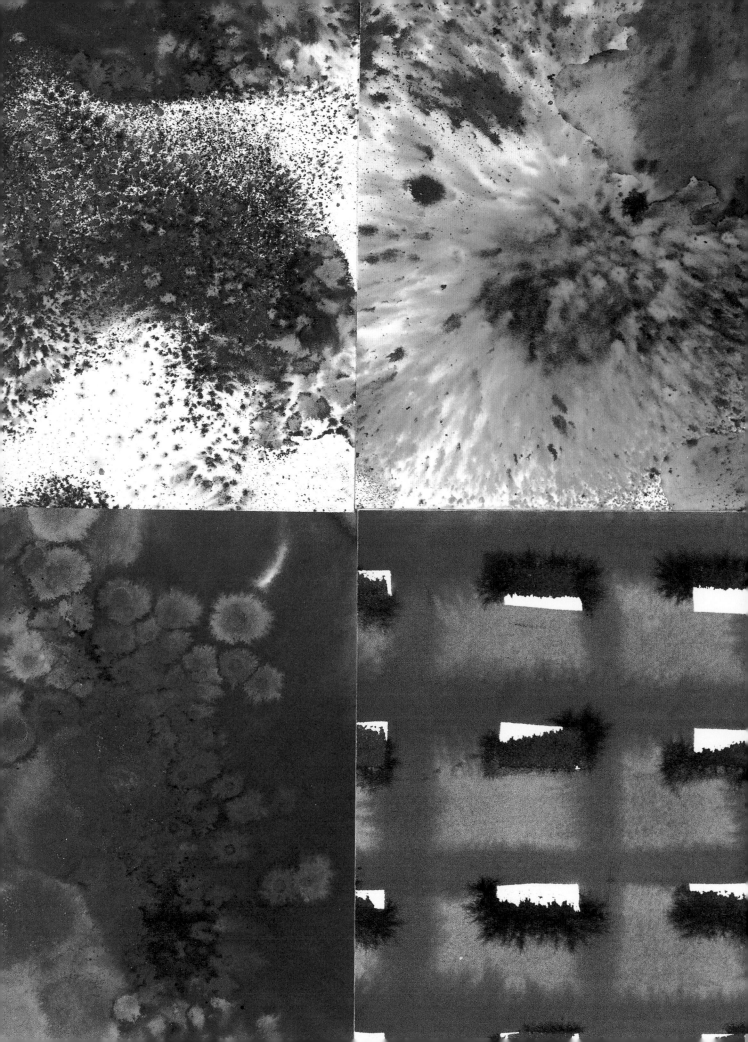

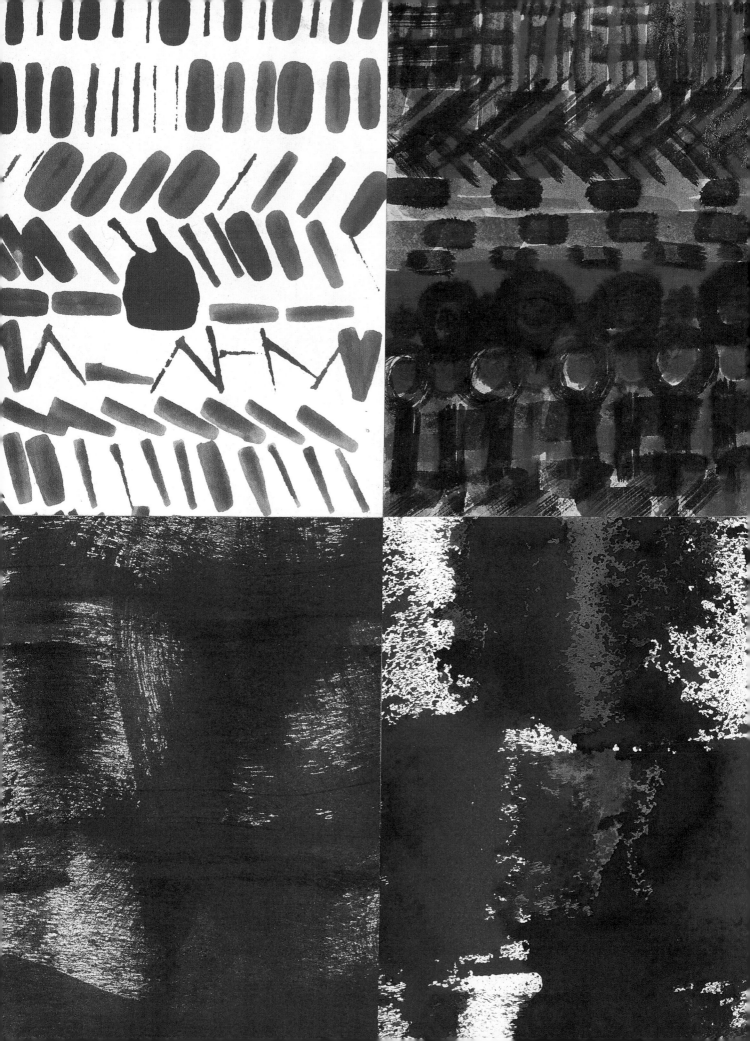

HINTS ON APPLYING INK

There are many different techniques. Try the following:

- Use the ink as a wash with a paintbrush. Different brushes will give different effects.
- Sponges and sponge brushes can be quick and give an even application or textural pattern depending on the nature of the sponge and pressure of the application.
- Large and small sponge rollers can be extremely effective for covering larger areas.
- Drop the inks onto a surface with a pipette, syringe or dropper.
- Apply by scattering small quantities of the powdered dyes onto previously wetted papers. As the colour is diluted it moves across the wet area, creating wonderful spreading shades and patterns.
- While the ink is wet, try placing rock salt on the surface of inked paper. This absorbs the ink, leaving small areas of paper undyed, each with a tiny halo of intense colour.

Facing page (above left:): orange ink applied with a small sponge brush.

Facing page (above right): turquoise, orange, gamboge and ultramarine ink painted on heavy Lokta paper with a dropper, bristle and soft brushes.

Facing page (below right): blue and purple ink applied lightly to cartridge paper with a sponge.

Facing page (below left): blue and purple ink applied by dragging a sponge roller across watercolour paper.

Yellow and red Markal Paintstiks applied to light Lokta paper and washed with turquoise Brusho ink.

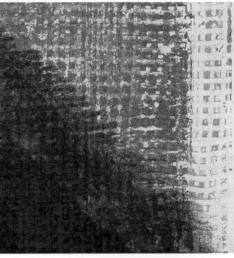
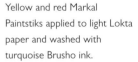

Bronze powders and metallic medium, glass-plate printed onto light Lokta paper, and painted with turquoise ink once the bronze powders had dried. The ink can affect the colour of the bronze powder if it is left to dry on the surface.

Yellow acrylic paint, glass-plate printed onto lightweight Lokta paper and washed with blue ink once the acrylic had dried.

ACRYLIC COLOURS AND MEDIUMS

ACRYLIC PAINT

Many people do not realize that acrylic paints can be used very effectively on fabric. In fact, they are excellent on any porous surface. There are many advantages in using acrylic on fabric for all types of application: it is readily available, it comes ready mixed and, once dry, is machine washable. It can be applied to any fabric or fibre, including leather, and is very effective when you need to print a light colour onto a dark ground. It is important that the acrylic is well adhered to the fabric, especially on shiny surfaces when the fabric may be less receptive. However, note that some acrylics, such as Chromacryl, are especially designed for use in schools where adhesion to fabric might not be so popular with parents. In this case a special textile medium must be added to it, and the colour must be heat-fixed for permanency.

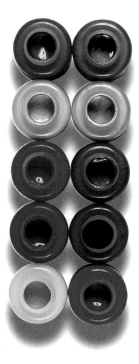

Above and below: a range of both jar and tube colours.

ACRYLIC COLOUR

These are available in a good range of intermixable colours, and are manufactured in both tube and jar form. Tube colour is usually slightly thicker, imitating oil paint, whereas the jar contents are slightly more liquid and so flow more easily. There are a number of manufacturers, including Liquitex, Rowney, Winsor & Newton, and Chromacryl. Acrylic can be diluted with water, but this weakens the actual colour, so if you want more liquidity use an extender such as Flow Aid which makes the paint runnier without reducing colour strength.

ACRYLIC METALLICS

These are similar to acrylic colour, and they have the same properties. There is a good range of metallics, including gold, stainless steel, bronze, copper, silver, and iridescent gold. They produce excellent metallic effects on all fabrics, as well as on different papers, card and wood.

IRIDESCENT TINTING MEDIUM

This medium consists of an acrylic base in which mica flakes are suspended to catch the light and

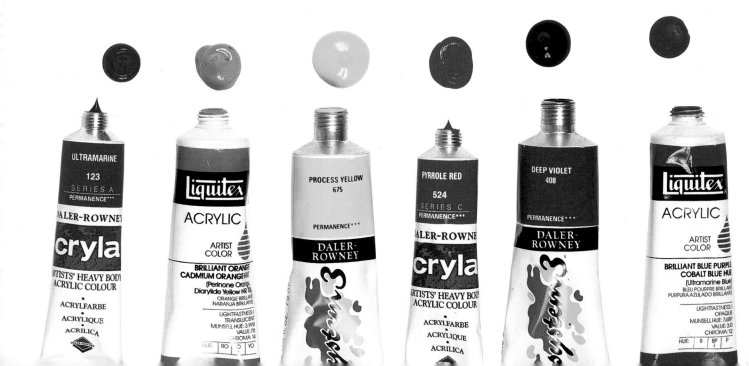

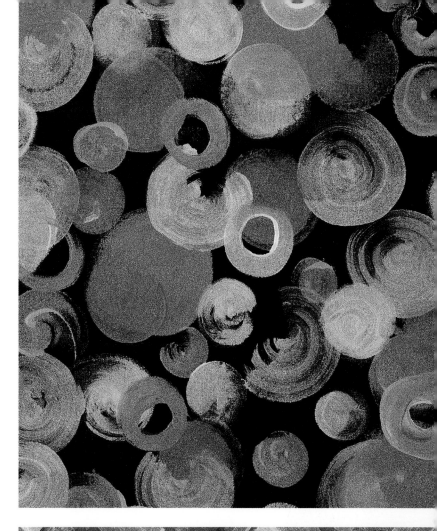

thus create a pearlescent effect. Add it to any acrylic colour to pearlize that colour. In fact, acrylic mediums can be mixed with any water-based colour, so iridescent tinting medium can be added to ink, dye, and gouache colours. Used alone it gives a translucent white, pearlescent finish.

ACRYLIC INTERFERENCE COLOURS

These are an extension of pearlized colours, but instead of having a silvery sheen they have a colour tint. (This is particularly visible when they are applied to a dark ground of fabric or paper.) Interference colours are either blue, purple, red, orange, green or gold. The colours can also be mixed with acrylic colours, but this must be done with a contrasting colour or the interference tint will not be visible.

ACRYLIC MEDIUMS

Mediums are available in different textures and finishes, including opaque, matt, flaky, rough and glistening. The following are particularly relevant to the techniques in this book:

- **Fabric Printing Medium** Helps to extend acrylic colour by making it more liquid, and makes the finished fabric less rigid. Its use does not dilute colour intensity.
- **Heavy Gel Medium** Makes the colour much stiffer and glutinous. The mix becomes transparent and remains raised on the fabric or paper surface. Mixing it with a range of metallics, interference colours or pure colour, can produce dramatic effects. Heavy gel medium can also be used with bronze powders and inks to give rich raised surfaces.

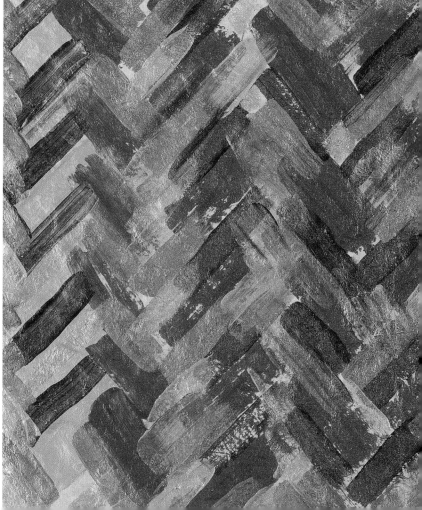

Above and below (right): metallic acrylics – gold, silver, stainless steel, bronze and copper painted onto navy fabric (above) and light Lokta paper (below).

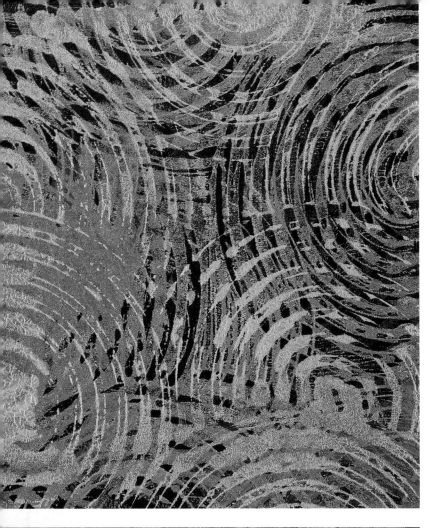

ACRYLIC GLOSS AND MATT VARNISH

These are excellent for sealing any surface which has been painted with a water-based colour. Once dry they are permanent and create a waterproof membrane. When acrylic varnish is mixed with a water-based colour, such as ink, it produces a thick, transparent paint which gives depth of colour as well as the opportunity to create matt or glossy surfaces. Add bronze powders to acrylic varnish to give work a glistening lustre.

ACRYLIC WAX

This has the feel and appearance of a wax but it is a water-based medium. It can be mixed with colour or bronze powders and has a slightly less transparent finish than acrylic varnish, but it gives very unusual and mysterious finishes to work. As it is water and heat resistant it is useful for a wide range of applications.

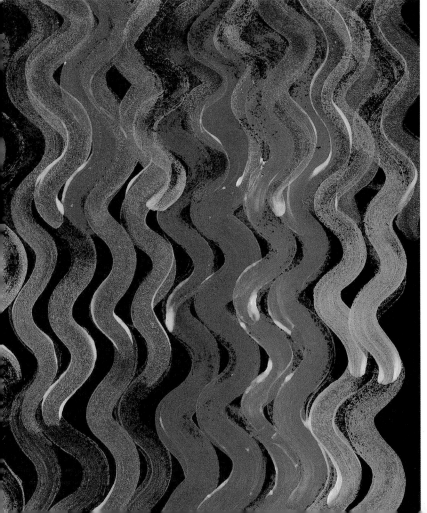

Above left: iridescent tinting medium mixed with blue and orange acrylic colour, and then glass-plate printed onto black fabric.

Left: interference gold, orange, red, purple, blue, and green acrylic colour, painted onto black paper.

Facing page: acrylic varnish mixed with inks and painted onto Lokta paper.

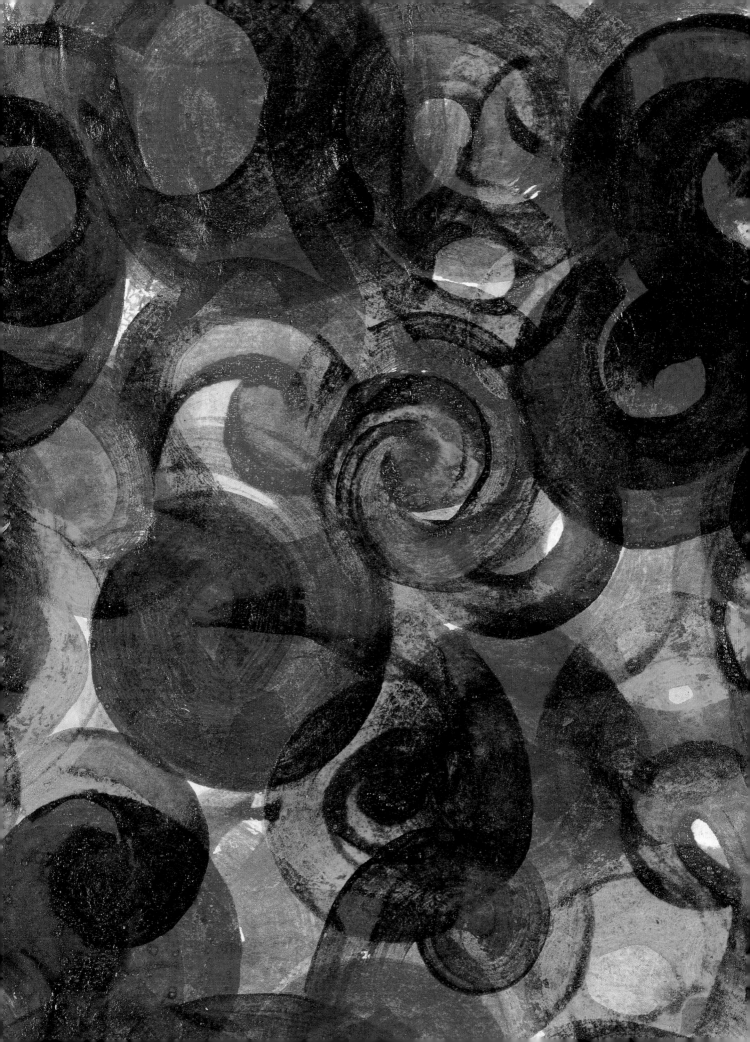

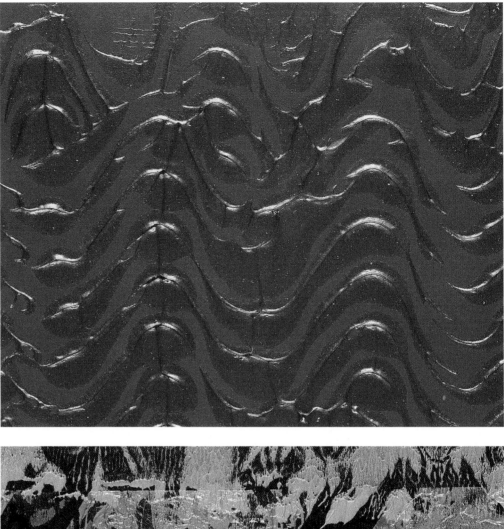

Right: heavy gel medium mixed with bronze acrylic and glass-plate printed onto paper.

Below right: heavy gel medium, mixed with metallic acrylics, and block printed onto dyed viscose-satin fabric.

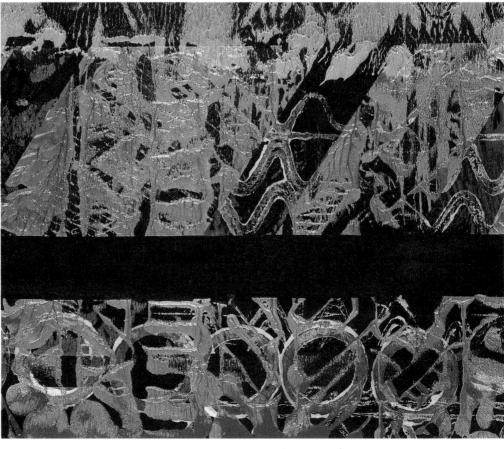

Facing page: acrylic wax mixed with bronze powders and painted over turquoise, purple and orange inked surface.

Next spread: montage using a selection of hand made Indian rag papers such as straw, wool, and Lokta papers, which have been printed and inked using various processes. The papers have then been cut using a template and the montage assembled.

BRONZE POWDERS

Bronze powders are in fact super-fine powdered metals. On first sight they may all appear to be very similar shades of gold, copper and silver. Closer examination will reveal that the golds vary from pale gold, which is quite delicate, through middle gold, which is darker and slightly green, to orange gold, which is a really rich brassy gold. On the other hand the copper is quite orange, while the antique copper is a deep, warm, almost ruby colour.

In order to use these powders you must mix them with a metallic medium, which will adhere the metal filings to whatever surface you wish to decorate. It is important to remember that these bronze powders are metal filings: always use a mask when tipping them from the phial into your mixing palette.

BRONZE POWDERS AND PAPER

For paper or hard surfaces you must mix bronze powders with metallic medium, which will act as a binder and dry clear. This medium is designed to be mixed with bronze powders so that when it is dry the powders do not lose their sheen and brilliance.

Jars and phials of bronze powders.

Once mixed, apply the powders in any way you wish, but remember that the binder may also adhere to your equipment and that, in a warm atmosphere, the mixture will dry quite quickly.

BRONZE POWDERS AND FABRIC

For fabric you need to mix the powders with a metallic fabric medium (Ormaline) or a metallic fabric binder available from screen-printing suppliers (see page 111). When mixing, pour out a tablespoon of the medium into a palette and carefully add about half a teaspoon of powder. Take care that it does not blow about as it is easy to inhale. If the mixture feels quite stiff and the colour seems about the same as that in the phial it will print with a clear metallic finish. If you do not add sufficient metallic powder the mixture will appear to have a 'bloom' (a slightly grey tint), and your print may be rather matt and glisten only a little. You can apply the mixture to the print surface by any method you prefer, but note that metallic fabric medium and most metallic binders are slightly adhesive and this will damage good brushes. A little careful practice in mixing, and conducting trials before embarking on a major project, will always be valuable and will avoid disappointing results. Metallic fabric medium also works well on paper, so you can work on fabric and paper simultaneously.

To begin with it is wise to choose natural fibres for your print surface, although experiments on fibre mixtures have been successful as have applications to leather. Once dry the fabric should be heat-fixed by ironing for at least four minutes at the heat setting suitable for the fabric used. The fabric should then be washed, preferably by hand, although gentle machine washing has not created any problems.

PEARL-LUSTRE POWDERS

These little tubs of indifferent, almost white, powder actually conceal delicately tinted pearl lustres in green, red, purple, blue, and even gold. Similar to the acrylic interference colours, the powders are fine titanium-coated mica flakes which, when mixed with either of the metallic mediums, give an unusual lustrous tint to a surface, especially when it is moved in light. Mixed with other colours, such as acrylics, the lustre powders give a subtle and attractive glisten to a surface. They can be mixed with metallic mediums as well as acrylic varnishes and acrylic wax to give exceptional results.

Bronze powders are available in:	*Pearl lustres are available in:*
Light gold	Pearl blue
Pale gold	Pearl green
Rich pale gold	Pearl purple
Middle gold	Pearl red
Orange gold	Lustre gold
Copper	Pearl lustre bronze
Deep copper	Glitter gold
Antique copper	
Fire copper	
Crimson copper	
Silver	

Powders and lustres need to be mixed with either metallic fabric medium (Ormaline) for fabric printing, or metallic paint medium for applying to paper and hard surfaces. Other acrylic mediums and gels can be mixed with bronze powders and applied to a variety of surfaces with considerable success.

TIP

Remember that bronze powders are fine metallic powders: always wear a mask when mixing them, to prevent inhalation.

Orange-gold bronze powder mixed with metallic fabric medium and applied with a roller onto green fabric.

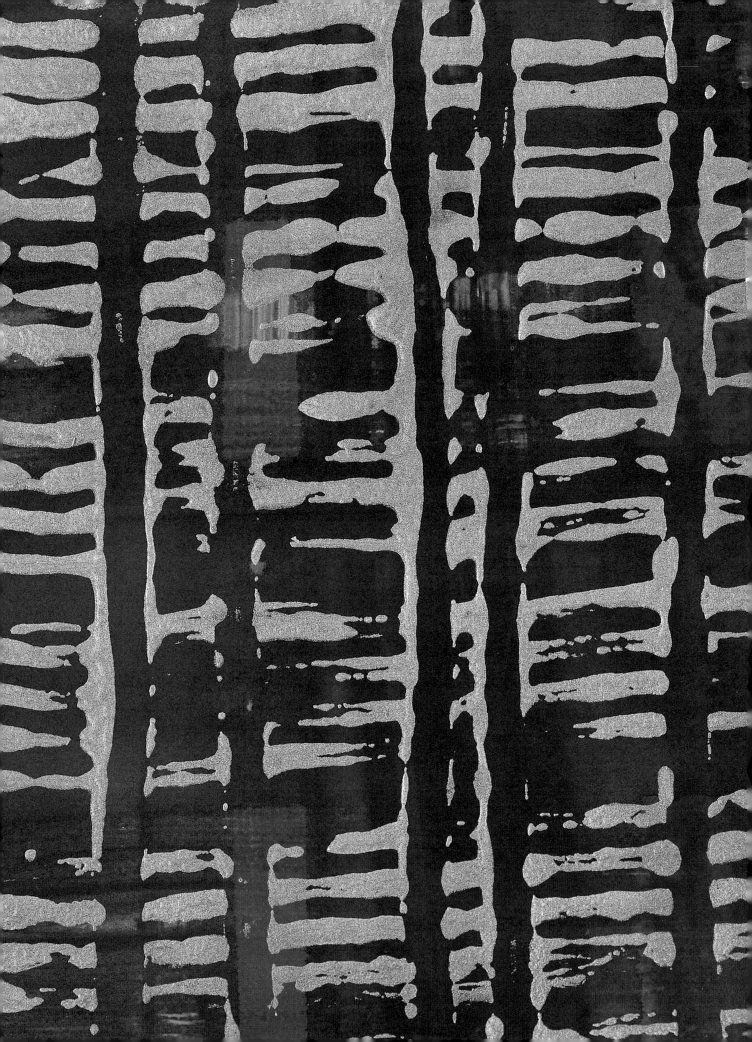

MARKAL PAINTSTIKS

Markal Paintstiks are a comparatively recent addition to the range of fabric mediums available. The pigment is manufactured in a mixture of oil and wax and produced as a chunky crayon in a card sleeve. Once the protective skin under the card is broken, you'll find a moist colour, quite like greasepaint, which is easy to apply by a variety of methods. The skin reseals after use, overnight, thus preventing the Paintstik from evaporating or deteriorating. Make sure that the piece of protective skin you cut away is discarded, as all parts of a Paintstik contain colouring pigments which will stain.

Paintstiks can be applied to any porous surface: paper, wood, plaster and fabric are all ideal, as is any fibre, whether man-made, synthetic or natural. It is permanent after about 48 hours, once the oil has evaporated and the colour has been absorbed into the surface. Fabrics should then be ironed; once the colour is fixed the fabric is fully machine washable and will retain both colour and surface finish.

Paintstiks come in 50 professional colours equivalent to artist's colours, two metallic colours, fourteen iridescent colours and six fluorescent colours. The colours can be blended to create a variety of shades and tones. There are two blending sticks: a pure blender which will extend the colour, and a pearlized one which will create iridescent effects with the professional colours. They can be blended together.

APPLICATION

Paintstiks can be applied directly onto fabric or paper by simply drawing the Paintstik on the surface. The soft colour will create thick areas of colour depending upon the pressure applied, but it is important to make sure that the colour is not applied too thickly or it will not key into the surface. The colour can then be worked in with a stencil brush or an old toothbrush, which helps to spread it and give a gradual build-up of colour as well as develop areas of shade. As Paintstiks are like large, soft crayons, all the usual mark-making techniques can be employed and areas of simple pattern can easily be created.

Markal can also be applied using masks and stencils (see pages 80–83), and you'll find that wonderful effects can easily be created with simple masking techniques. Lines of masking tape attached to the fabric can create grids, meshes and

Facing page: gold bronze powder mixed with metallic medium and glass-plate printed onto previously inked paper.

Left: selection of Markal Paintstiks, both professional and iridescent colours as well as blending sticks.

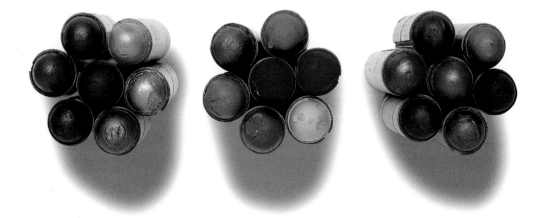

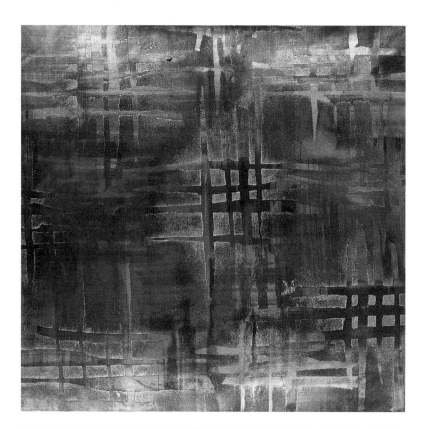

geometric patterns. It is amazing how far the colour will carry and how quickly it will tint or colour the surface. Remove the masking tape and place it onto another area to build up the coloured surface. Stencils can be used to build up patterns in the same way, first applying colour to the surface of the stencil and then brushing it off onto the surface with an old toothbrush. On fabric, a stencil cut from sticky-backed plastic (Fablon) makes an excellent mask, but even a paper mask works well as the softness of the Paintstik responds to every minor change in the edge of the paper (e.g. a tear or cut).

Paintstiks are sensitive to the most delicate of textures placed underneath fabric or fine paper. Delicate fabrics such as lace are sufficiently textured to create a rubbed pattern. Take care not to make the layer of Markal too thick, or the colour may be inclined to peel off. All kinds of surfaces can be used to create patterns for rubbing: old wooden blocks, decorative embossed wallpapers, or make your own blocks from string, lino or wood (see pages 72–75).

Top left: dyed viscose-satin fabric painted with dye to give a variegated background colour. Slithers of masking tape were torn and stuck onto the fabric and iridescent green, blue, gold and silver Markal Paintstiks were brushed over the surface of the fabric. This creates a transparent effect, especially with the blue and green colouring.

Left: Markal professional colours – azo yellow, naphthol red and cobalt blue, used directly on handmade paper.

Facing page: Markal iridescent Paintstiks – blue, purple and green – rubbed over a string block under black fabric.

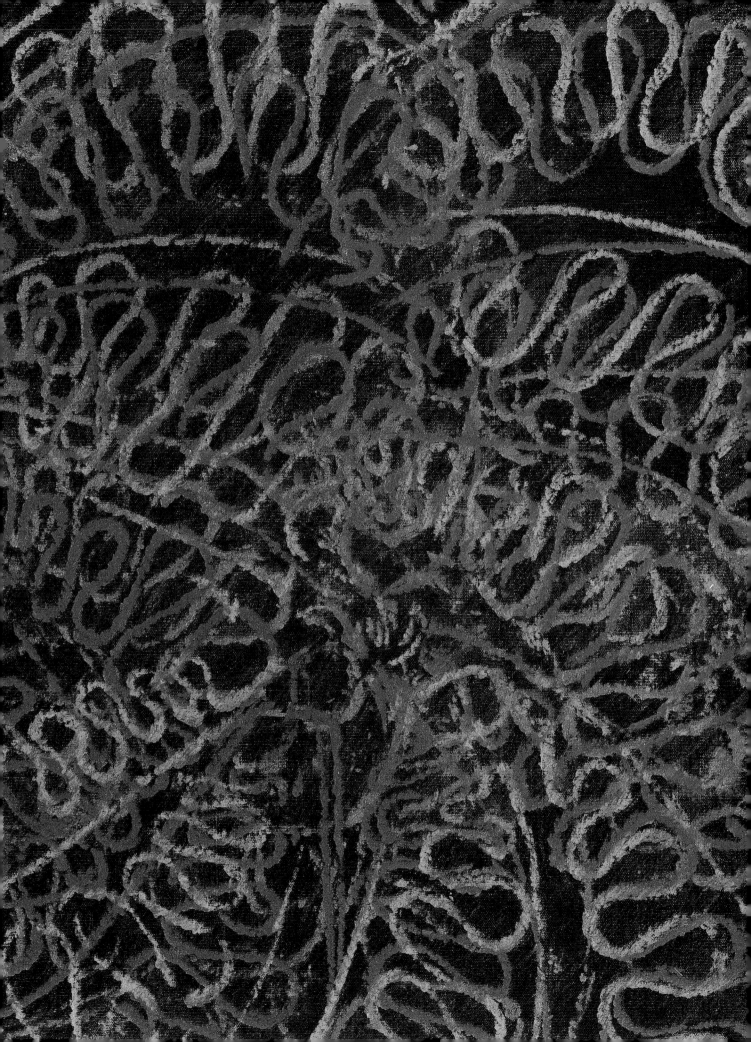

E Q U I P M E N T

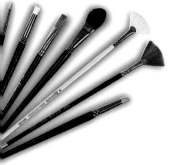

When colouring papers and fabrics certain pieces of equipment are useful, others essential. You'll soon discover that each piece of equipment can achieve various effects according to the colouring mediums applied and the fabric or paper used.

BRUSHES

Brushes are made in a wide range of sizes and types. Stiff-bristle brushes are designed to be used with thicker, heavier painting mediums, whereas more delicate brushes, such as sable and squirrel, have been designed for use with lighter mediums such as watercolour. Brushes have different shapes – square, pointed, rounded and fan – designed to create specific types of finish and line when used with liquid colour; and they have different head thicknesses, so they can carry varying quantities of liquid colour in the 'belly'. This ability to hold the medium is important because it prolongs the continuous flowing of colours from the brush.

For most of the techniques used in this book, a small variety of brushes is adequate. You'll need a good, wide soft-bristle or man-made brush for rapidly applying colour to paper, a fan brush to create unusual patterns, and a few soft, fine, pointed brushes. Try a man-made imitation of sable, such as Dalon, Prolene or Liquitex. These come in a wide range, from fine, thin brushes to broad, flat and square brushes.

SHAPED PLASTIC BRUSHES

Like traditional brushes, plastic brushes come in a range of different head shapes and sizes. They are excellent for applying colour directly onto paper or for drawing into thick acrylic, either on a glass plate or on paper.

SPONGE BRUSHES

Sponge brushes are an excellent tool as they absorb a large quantity of liquid colour quickly, especially dye and ink, and are easy to use to cover paper and fabric with flat areas of thin, water-based colour. They come in four different widths, and are usually black, blade-shaped sponges with short wooden handles. When loaded with colour they are easy to draw with, producing large, broad strokes as well as abrupt lines. Sponge brushes tend to clog easily with acrylic colour if they are not thoroughly washed in cold water before the colour dries.

SPONGE ROLLERS

Made from a different density of foam than a sponge brush, these come in a variety of sizes and qualities and are similar to a miniature version of a decorating roller. Small, cheap, plastic rollers in various widths, and large, more substantial rollers with stronger plastic handles are also available. Both types of roller have their uses as they create different effects, although an investment in a large sponge roller is worth while if you want to colour large areas of fabric and paper. Again, care in cleaning these rollers is required as the surface will become clogged with acrylic if it is allowed to dry.

PRINTING ROLLERS

These are hard rubber rollers, often associated with traditional lino-inking. They are excellent for applying acrylic and mixed bronze powders to glass plates and printing blocks as well as directly onto paper and fabric. Made of a dense rubber they are not so sensitive to applications of acrylic as sponge rollers, but do require careful regular cleaning in order to maintain a good workable surface.

TOUGHENED GLASS PLATE

A toughened glass plate provides a versatile surface which can be used either as a palette or as a printing surface with designs drawn onto the ready-inked surface. Toughened glass is excellent as it is transparent, easy to clean, shiny and safe. Other surfaces, such as perspex or acetate sheet, can be used as substitutes, although perspex tends to scratch and acetate sheet tends to stain. Glass must have its edges ground to prevent cuts, and it must be thick as some of the printing techniques create a strong suction and thin glass may break. An A4 piece of glass is easy to handle and matches paper sizes.

PALETTE

A good mixing palette is very beneficial when colouring and printing fabric and paper, and a wide range of plastic palettes are available. A large radial palette is useful as colours can be mixed in larger quantities and then used with a range of brushes and sponge brushes.

MASKS AND STENCILS

Throughout the book a variety of different masks and stencils is used. Masking tape is used extensively as it is a very flexible material and readily available in a variety of widths. Masking tape can be cut and arranged to create symmetrical patterns or torn to create more random effects. Sticky-backed plastic (Fablon) can be used when a stencil or mask is required for a larger area of fabric. The mask or stencil is cut out from the sticky-backed plastic, the protective backing removed, and the mask applied to the fabric. (This is not suitable for paper work as the adhesive on the plastic is too strong for the paper and will tear it.) Also useful is freezer paper or the wrapping around photocopy-paper packs. These papers have a coating which, when ironed, will temporarily adhere the paper to a fabric. However they do tend to peel off if they become too wet.

BLOCKS FOR PRINTING AND RUBBING

Simple and effective printing blocks can be created with a good quality double-sided sticky tape and a firm piece of board. The surface of the board is covered with double sided tape and the string arranged in a pattern onto the tape. (See page 72.) It is important to select a string that is fat enough and firm enough to create a reasonable raised surface and that will not become flattened when pressed hard.

PIPETTES AND SYRINGES

These are useful when diluting, mixing or transferring dye or liquid colour. Pipettes are relatively cheap to acquire and are invaluable when there are a number of different colours to be selected, mixed and used. .

PALETTE KNIFE

Palette knives come in a variety of different shapes and sizes. They are particularly useful for mixing acrylic colour as well as bronze powders and metallic mediums. It is possible to use a brush to mix these materials, but it is more effective and economical with a palette knife. They are also useful for applying colour rather than a brush or sponge brush.

CRAFT KNIFE

A small, sharp craft knife is essential for cutting stencils. The finer the knife and the slimmer the handle the more control the fingers have in creating the correct shape and refinement to the lines being cut. Craft knives are available in a wide range of different forms, from cheap and disposable to the more substantial blade holders with renewable scalpel blades. Selection of your craft knife is important as you need to find it comfortable in your hand and feel that you are able to control it. Care must always be taken when using and storing a craft knife or scalpel as the blades are often very sharp (sometimes surgical) and can easily inflict severe cuts.

Next spread: brushes – soft man-made, natural very soft squirrel hair, bristle fan brush; plastic shaper brushes; sponge brushes; firm sponge rollers; glass plate; hard printing rollers; palette knife; pipettes; and craft knife.

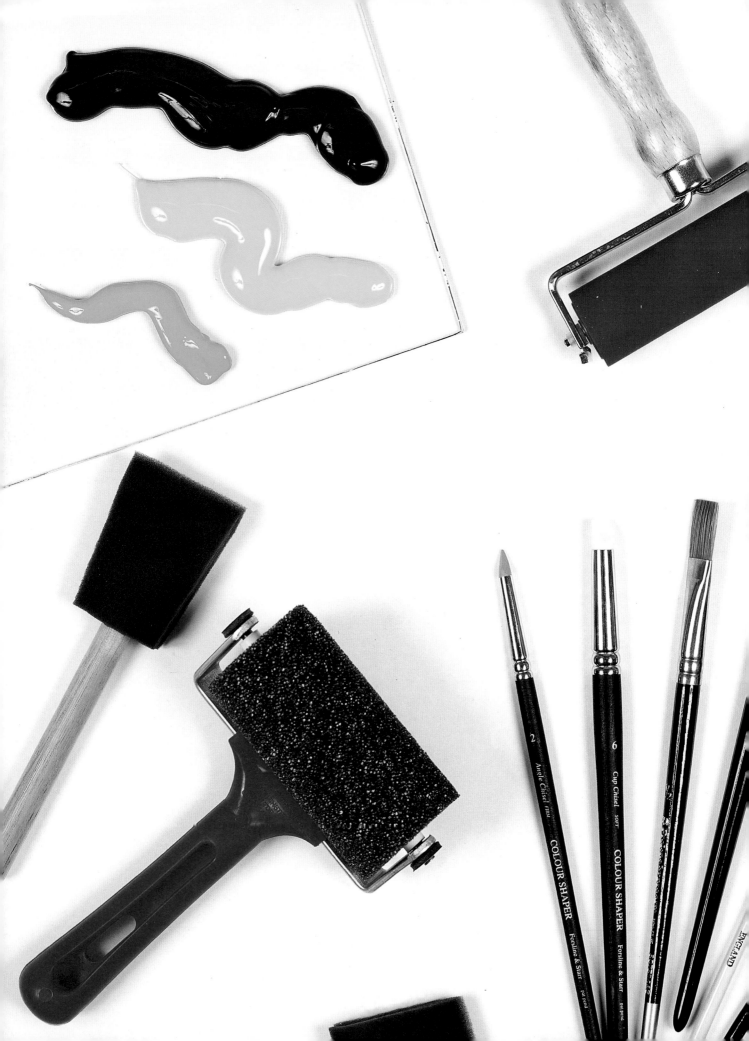

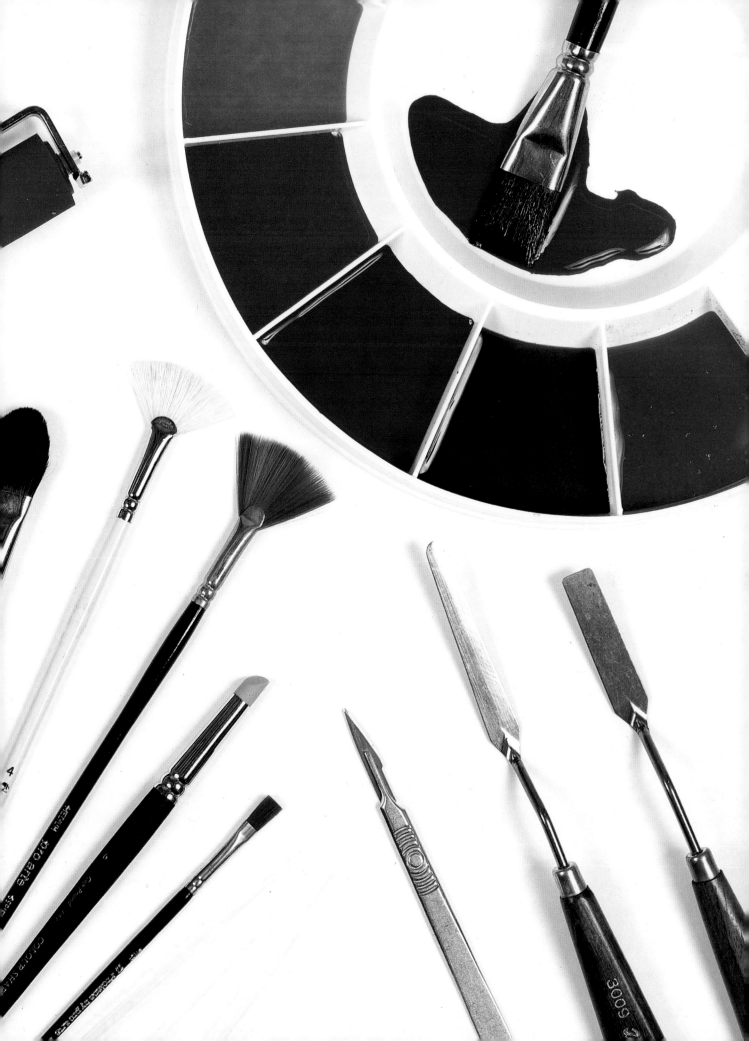

CHAPTER 2

BASIC TECHNIQUES

This chapter details methods of applying colour to both paper and fabric,

suggesting different ways of using the equipment listed in the previous

chapter. An immense variety of effects can be created, depending on the equipment

used and on the differing papers, fabrics, and colouring mediums chosen.

Always remember that results will vary from person to person, so don't feel

that you have failed if you do not get the result you want immediately.

In fact, it is worth keeping so called 'failures'; they can often be reprinted

or inked over, and may well become your favourite pieces! Just allow

yourself time to play and see what effects you can get.

DYE RECIPES

he following recipes can be used on all natural fibres, as well as on mixtures of natural and synthetic fibres (although in the latter the results will be more variable). The recipes given here provide the greatest flexibility when colouring fabric with dye. The basic dye recipe consists of urea salt (acidic) plus cold-water powder dye plus washing soda (alkaline).

IMMERSION DYEING

Immersion dyeing is when fabric is totally immersed in a bucket of prepared dye, left for at least an hour, removed and rinsed. The fabric should have an even colour and can then be redyed in a second colour, or left as it is.

IMMERSION DYE RECIPE

This recipe is suitable for 2–3 metres (6½–10 ft) of medium weight cotton. Depth of colour is dependent on the ratio of dye to water used and the nature of the fabric. The dye bath is only stable for two to three hours once the washing soda has been added.

Materials

2–3 m (6½–10 ft) cotton fabric
1–3 teaspoons dye powder
2 level tablespoons urea
4 level tablespoons salt
1 level tablespoon washing soda
measuring jug
dye bath (e.g. bucket)
water

Method

1 Mix the dye powder with a small amount of warm water to make a smooth paste. The quantity of dye powder and water used will affect the resulting colour.
2 In a separate container, dissolve the urea in 570 ml (1 pt) of lukewarm water. Add to the dye paste.
3 In a clean bucket, dissolve the salt in 570 ml (1 pt) of boiling water. Add this salt solution to the dye mixture. Allow the water to cool, adding more water if necessary so that the fabric can move freely in the bucket.
4 Prewash and wet the fabric, then squeeze out excess moisture.
5 Place the fabric in the dye bath, ensuring that the fabric is not folded and is submerged. Stir continuously for six minutes.
6 Dissolve the washing soda in a little warm water and add to the dye bath. Allow the fabric to soak for another 45 minutes at least, stirring occasionally.
7 Remove fabric from the dye bath and rinse until the water runs clear. Allow it to dry naturally for at least 24 hours.

DIRECT FABRIC PAINTING

For painting directly onto fabric, the dye is mixed up in a very concentrated form using a thin paint recipe so that it can be applied directly onto fabric using a brush, sponge, spray bottle or sponge roller. This is an extremely flexible method of applying a number of colours at one time, and gives you the freedom to colour the fabric with a variety of different effects.

The thin paint recipe is easy to make, especially if a little preparation is done in advance.

Make up the following two solutions in separate airtight plastic containers and label accordingly. The solutions will keep indefinitely.

CHEMICAL WATER RECIPE

Materials

1 litre (1¾ pt) warm water

140 g (5 oz) urea

5 g (¼ oz) Calgon

10 g (½ oz) resist salt L (not essential but beneficial)

Method

Dissolve all ingredients in the water, label and store in an airtight container.

WASHING SODA SOLUTION RECIPE

Materials

1 litre (1¾ pt) very hot water

200 g (7 oz) washing soda or soda ash

Method

Dissolve the soda in the water, label, and store in an airtight container.

THIN PAINT RECIPE

Materials *(for each dye colour):*

¼ – ½ teaspoon of dye powder

warm water

25 ml (1 fl oz) chemical water

25 ml (1 fl oz) washing soda solution

fabric (approx 0.5 metre, depending on
 fabric density)

frame or polythene sheet

pins

brushes/sponge brushes/rollers/spray bottle

Method

1 Dissolve the dye powder in a very small amount of warm water.

2 Add the chemical water and the washing soda solution and mix well. The thin paint is now ready to be painted directly onto any natural fibre.

3 Stretch and pin the fabric over a frame and apply the paint with brushes, sponge brushes, sponge rollers and even a spray bottle. Alternatively, lay the fabric on polythene to paint. (Care must be taken not to flood the fabric when working on polythene.)

4 Allow the painted areas to dry, then add further applications of colour if they are not dark enough.

5 When dry, the fabric can be rinsed in cold water. Some excess dye will inevitably wash out at this point, but subsequent rinses should give clear water depending on the dye colour and the nature of the fabric. If possible leave the fabric for 48 hours before rinsing.

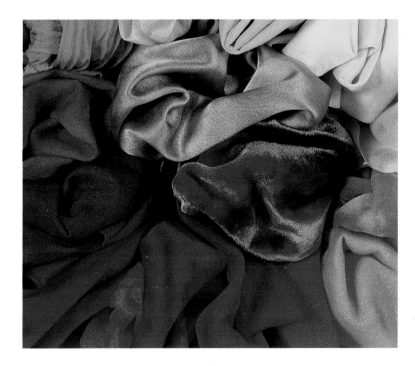

SPONGES, ROLLERS AND BRUSHES

A|ll sponges absorb a reasonable quantity of liquid colour and so are particularly effective when used with inks and dyes. Sponges vary in density and this can be used to create both solid colour as well as for applying the colour unevenly and tonally.

PAPER APPLICATION

It is worth clearing a large area to put wet papers on to dry because once you start colouring papers, you will find that your imagination will begin to flow and suddenly you will be creating a seemingly endless collection of papers. As regards paper, initially select a variety of different plain white or cream papers (e.g. cartridge and tissue), and some brown paper. Choose a few coloured dyes or inks to begin with, and place them in a large palette or in a series of shallow dishes. Remember that dyes and inks are very fluid and transparent in colour, so once one colour is dry another can be painted onto it to change the original colour.

Materials

coloured inks, diluted Brusho, or concentrated dyes
palette or shallow dishes
white, cream and brown paper
sponge
sponge roller
sponge brush

Suggested effects

- Take the sponge roller, roll it in the ink, then lightly roll it across the paper. Try this on cartridge, then on tissue and then on brown paper. See how the ink sinks into the different papers, and observe how the application of colour alters as the roller becomes drier. You will see areas of flat colour followed by areas of partial colour followed by larger areas of white.

- Try taking the roller up and down in lines (like mowing a lawn) to create stripes of one colour, but with different tones. If you want to introduce a different colour, do alternate lines with a sponge brush or rinse and reuse the sponge roller, but remember to squeeze out excess water as this will dilute the strength of the inks and dyes.

- Having done lines with the sponge roller, run the roller at right angles, perhaps with another colour, to create checks, grids, squares, and tartans. Every time you add further colours, additional colours will appear because of the transparent quality of the inks and dyes.

- Try applying ink to the roller unevenly so that it will give solid areas of colour to contrast with more open areas of colour.

- Dip the sponge brush into ink and, using just the tip of the brush, gently print with it, creating short, even marks. Paint these into lines, running parallel to each other, or work a herringbone pattern, or cross the lines over each other, or run them in semicircles like wheels to create movement and texture. Try this in one, two and three colours.

- Try the same effect, making simple lines with the end of the brush, but with different size brushes so that the rhythm of the pattern alters. Try dragging the brush across the papers in broad sweeps until the ink runs out, make the sponge brush wave, wriggle and turn. Press the sponge brush hard and it will flood the ink; press it gently and the colour will be more controlled.

Facing page (above): four different ways of using a sponge brush to create simple patterns.

Facing page (below, clockwise from top left): colours added to blue with a sponge brush, on wool Indian rag paper which creates a different effect; circles painted with a sponge brush onto watercolour paper; various water-based inks painted with different widths of sponge brush onto heavy cartridge paper; second and third colours added to the original blue, using a sponge brush on watercolour paper.

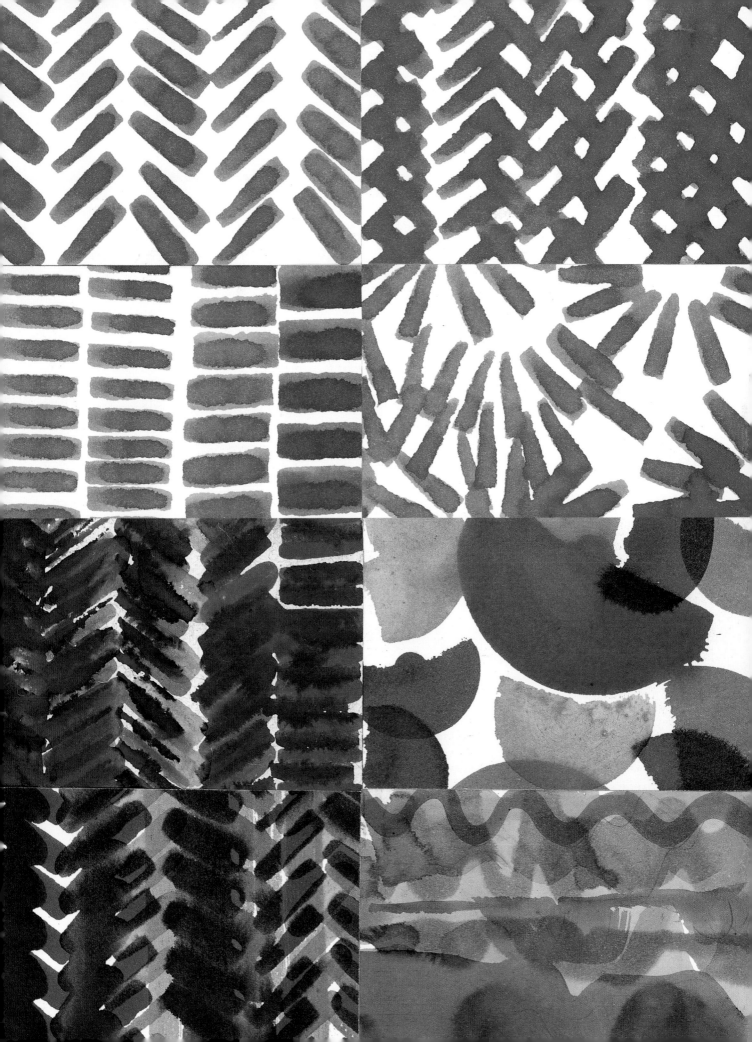

Remember that all these effects will alter depending on the paper they are applied to and whether they are applied wet onto wet or wet onto dry paper. Try further experiments on different sorts of paper, such as Asian or handmade.

FABRIC APPLICATION

For this technique you will need to mix up the dye according to the thin paint recipe (see page 53). Make up small quantities initially until you see how much dye your fabric will absorb, how strong the colours are, and whether the effect is to your liking. It is easy to make up further batches of dye, as long as you record how much dye powder you have mixed with the chemical water and the washing soda solution.

Select a variety of small pieces of fabric of natural fibre, such as silk habutai, silk dupion, cotton calico, cotton poplin, muslin, and viscose satin. Make sure they are all well washed so that no dressing is left to prevent dye absorption.

Materials

assorted fabrics

thin paint solution

frame and pins

a sheet of medium-weight polythene

sponge

sponge roller

sponge brush

heated wax or gutta (optional)

Suggested effects

● Try dividing each fabric in half, dampening one half to see how the dye responds to a wet or dry surface.

● Place your fabrics onto a sheet of polythene or stretch and pin them onto simple frames. Paint the dye onto the fabrics using rollers, sponge brushes and sponges, using the same techniques as for colouring papers (see page

54). Different fabrics will absorb the dyes at different rates; even different weaves and the spin of the threads will affect the absorbency. Give the fabrics time to absorb the dye and leave on the polythene or frame to dry.

● To build up colour intensity, paint the fabrics with the dye a second time. The dye will gradually be absorbed into the fabric as it is drying, sometimes quite rapidly so that the colours become merged. Experiment with different types of fabric to achieve different results.

● Keep an area of fabric clear of dye by using a resist (either heated wax or gutta) to prevent dye absorption. Less controlled areas of white fabric can be kept by carefully restricting the dye which floods onto the surrounding fabric. As always, the effect will depend on the weight, weave and fibre of the fabric.

● Once you have experimented with sponges, sponge rollers, and sponge brushes, try applying dye with a variety of brushes.

Method

1 Once the fabric is dry, let it absorb the colour for 48 hours and then rinse in cold water. Do not be alarmed when the dye appears to be washing out. It is very difficult to judge precisely the quantity of dye necessary for the different fibres when using this method, so excess dye is inevitable. With each rinsing the quantity of excess dye should reduce until the water runs clear. Carefully hang the fabric out and let it dry naturally, then iron.

2 This method of colouring fabric is very flexible, giving freedom to create unique pieces in their own right or as backgrounds for further printed techniques. Painted pieces of fabric can be further dyed, once rinsed, by immersing them in buckets of dye. This simple technique will alter the colours but not the applied patterns and it often produces wonderfully exotic fabrics.

Facing page: cream viscose satin painted with turquoise, scarlet and golden yellow Procion dye, mixed as a thin dye and applied with a sponge brush.

Below: thick cotton calico painted with blue, turquoise and tan Procion dye with a sponge roller.

GLASS-PLATE PRINTING

Glass-plate printing is an excellent method of producing a unique and spontaneous image for quick application to paper or fabric. In order to achieve effective and successful results it is worth spending time becoming familiar with the basic technique of inking the plate and the differing nature of the printing inks, on this occasion either acrylic colour or bronze powders and mediums.

GLASS-PLATE PRINTING AND ACRYLIC PAINT

Acrylic colour comes in either tubes or jars; tube colour is less fluid than jar colour, and this becomes very evident when applying it to a glass plate. Tube colour is quite tacky when wet, and less likely to move when drawn into, but this makes it less flexible and rather thicker when dry on fabric, and to a lesser degree on paper, than jar colour. Jar colour's fluidity can make it less adhesive, which is a disadvantage when rolling it out onto a glass plate, but the increased flexibility, especially on fabric, can be helpful. Add acrylic gel to thicken the colour and give it a raised surface when dry.

In the end, the consistency of all acrylic is dependent on how many colours are mixed together and how much colour is put onto the glass plate, but the addition of acrylic mediums (extenders), which make the colour more fluid without diluting colour intensity, are worth considering. Acrylic colour is permanent on fabric but can make the fabric feel rather stiff.

Facing page: scarlet and yellow acrylic applied to a glass plate, then drawn into with a plastic shaper brush. The design was then printed onto fine coloured Lokta paper.

GLASS-PLATE PRINTING ON PAPER WITH ACRYLIC

The quality of a print will be affected by the nature of the paper that is selected – whether it is fine, rough, smooth or thick. Take time to make experimental prints on different weights of paper, such as tissue and cartridge, as well as handmade Asian or South American papers.

Materials

different varieties and weights of paper
glass plate
one or two rollers
acrylic colour (tube or jar)
old comb or shaped plastic brush

Method

1 Squeeze a small amount (about two teaspoonfuls) of colour onto your glass plate.
2 Roller the colour across the plate until the plate has an even coating and is not too dry. Make sure that the colour does not flow off the glass plate. Add more colour if covering the plate is difficult.
3 Quickly draw into the surface of the coloured plate using your finger, the plastic brush or the comb. If you cannot get the design right first time, just run the roller across the plate and start drawing again. Once you have a pattern that you find pleasing, you are ready to print.
4 Carefully place a sheet of cartridge paper on top of your coloured plate and gently press down to allow the paper to contact the colour and your design.
5 Gently peel back the paper to reveal your print. Remember, it will be a reverse image.

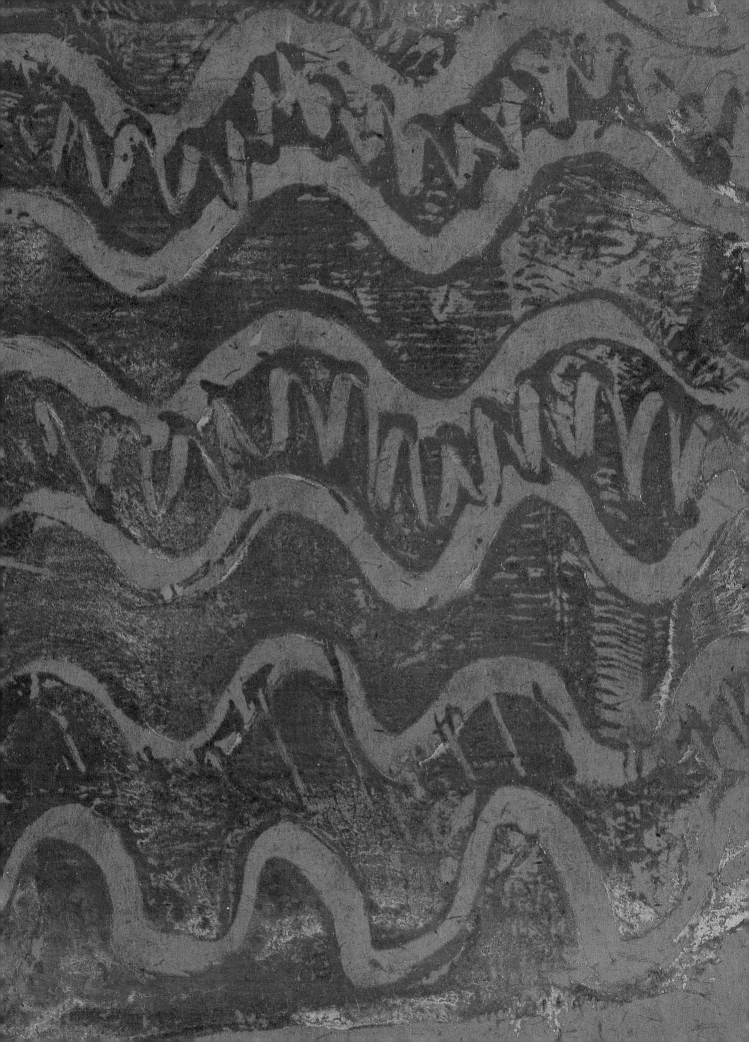

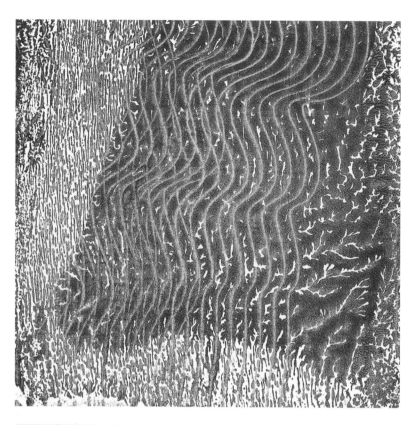

TIP
A second print may be possible if sufficient colour remains on the glass plate. Lighter weight paper can be used to print with the residue of the acrylic.

Further effects

- Place the paper face down on the coloured plate, and draw onto the back of the paper with a hard pencil. This will create clearly defined dark lines in your print. (This is known as monoprinting.)

- Lay the paper on a flat surface and then place the glass plate on top of the paper. This is a handy technique if precise positioning is required.

- Let the first print dry and add a further print, perhaps in a second colour or in a lighter tone of the first one.

- Mix two colours on the glass plate. Swirl these around with the roller before drawing into them.

- Mix a dark colour with iridescent tinting medium. This will pearlize the colour, to produce all kinds of glistening effects. It is particularly effective on dark paper.

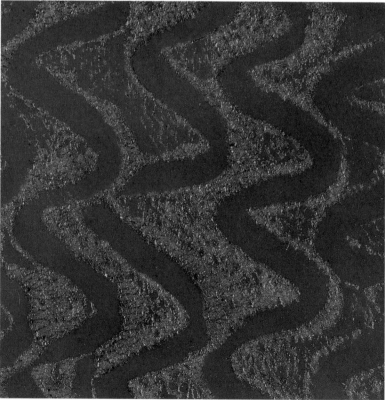

Above left: monoprint using the technique of drawing onto the back of the paper with a comb while it is in contact with the glass plate.

Facing page: monoprint using a series of prints built up on the paper with successive prints in three colours.

Left: iridescent tinting medium mixed with teal acrylic, glass plate printed onto tea Asian rag paper and over-inked with blue ink.

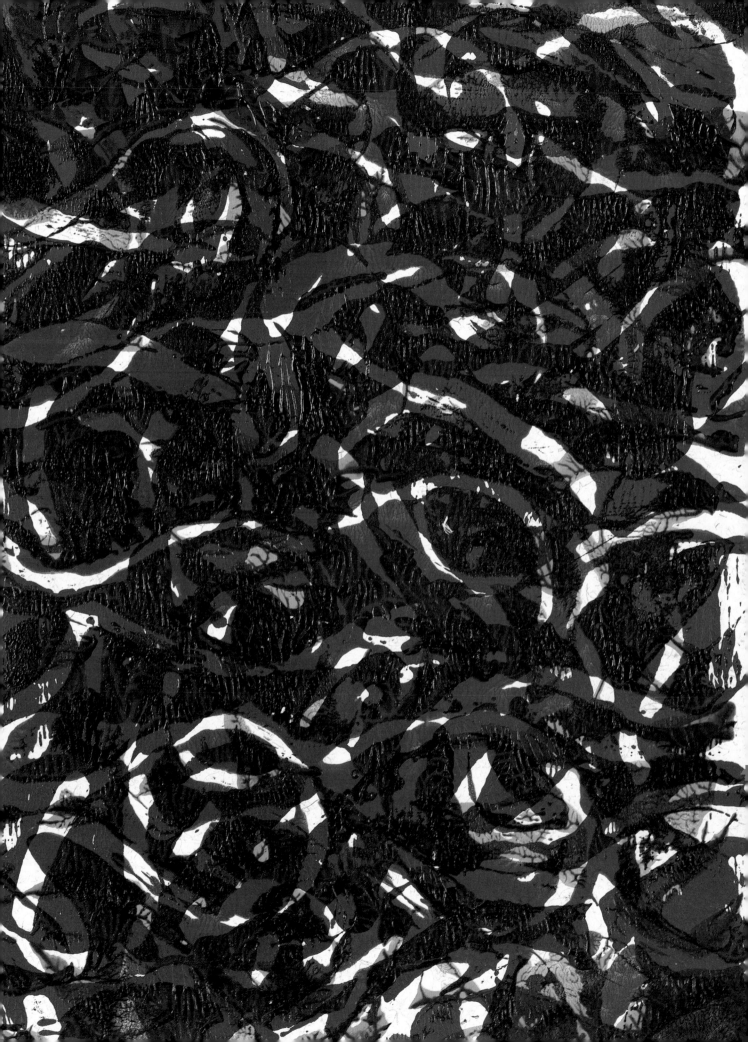

GLASS-PLATE PRINTING ON PAPER USING TWO PLATES

Having mastered the application of colour to one glass plate, it is well worth exploring the effects of using two.

Materials

paper

two glass plates

one or two rollers

acrylic colour (tube or jar)

old comb or shaped plastic brush

palette knife

Method

1 Squeeze two generous teaspoonfuls of acrylic colour onto one glass plate and roller the colour across the plate.

2 Take the second sheet of glass and place it on the inked face of the first sheet.

3 Using a blunt knife or palette knife, gently prise the two plates apart. The acrylic will have created a wonderful organic pattern that will vary depending on the thickness of the acrylic applied.

4 Print either glass plate onto paper as before, but this time there will be a mirrored version to print from your second glass plate.

Further effects

● Colour one plate thickly, draw into it, and press the plates gently together, to create a textured but drawn mirror image to print.

● Colour one plate all over, apply the second plate, then twist the two plates around before prising apart. The pattern created will have been dragged in a circular movement and is particularly effective when using more than one colour.

● Place small blobs of different acrylic colour onto the glass plate. Without rolling the surface, squeeze the two glass plates together to spread the colour in a different way.

Red and yellow acrylic applied between two glass plates, pulled apart, and contact-printed onto turquoise paper.

GLASS-PLATE PRINTING ON PAPER WITH BRONZE POWDERS AND METALLIC PAINT MEDIUM

For an introduction to how to mix bronze powders and metallic paint medium, refer to the section on bronze powders (see page 40). Mixing a reasonable amount of bronze powder and metallic medium in small screw-topped jars ready for use is easy, safe and quick, and the contents do not seem to deteriorate if used within a short time, such as a week.

Mixing bronze powder with metallic paint medium, or metallic fabric medium, directly on a glass plate is quite possible. However, you'll find it a more liquid mix than some acrylic mixtures and, if it is too liquid when drawing into the surface, the medium may re-form and your design will be lost. If consistency becomes a problem, either add more bronze powder or less medium. The quality of the liquid mixtures will be affected by atmosphere, heat, and the humidity of the room at the time of printing.

Once the bronze powders and medium are applied to a glass plate they can be printed using the same methods as for acrylic, although allowance needs to be made for the slight change in consistency.

Bronze powders will intermix, so subtle shades of silver, gold and copper can be achieved. Mix them with coloured metals, pearl powders and lustre powders to give extra depth and mystery.

Above right: yellow and red acrylic placed between two glass plates, twisted apart and printed directly onto yellow paper.

Right: gold bronze powder, mixed with metallic medium, and glass-plate printed onto Lokta paper. Once dry the print was over-inked using turquoise and ultramarine Brusho to make the paper surface cockle.

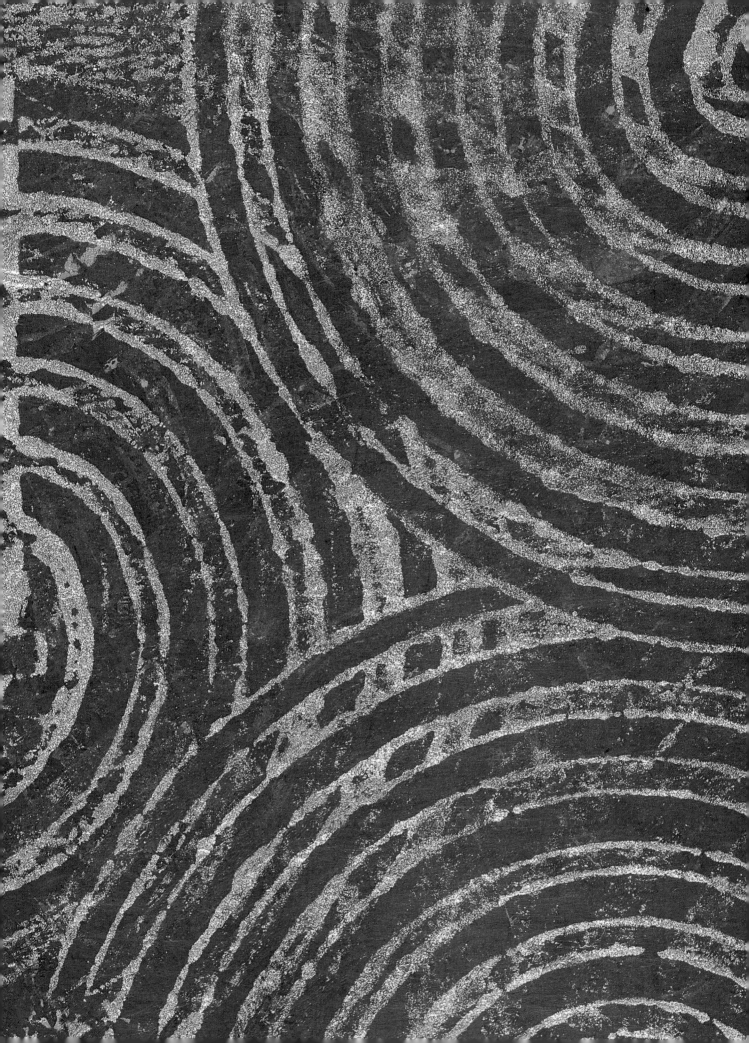

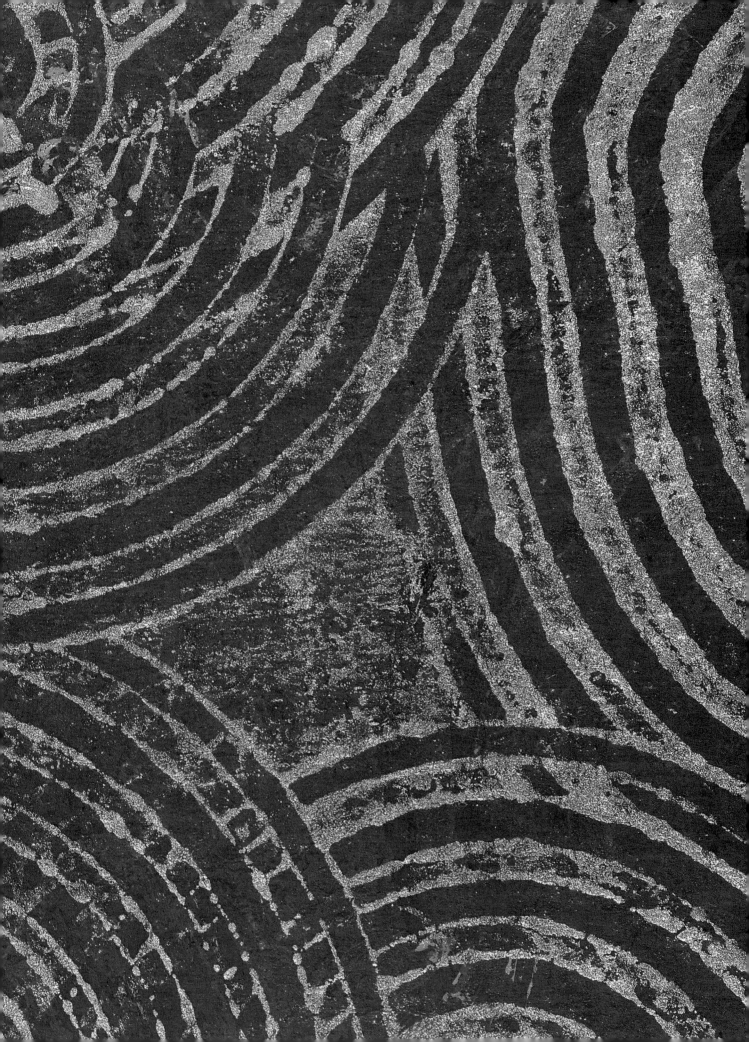

GLASS-PLATE PRINTING ON FABRIC WITH ACRYLIC

Printing with acrylic colour can produce excellent results on a wide range of different fabrics, both natural and synthetic, but it can make the fabric feel rather stiff. You can make the colour softer by adding a fabric medium that will extend the acrylic base, making it more liquid without diluting colour intensity. Many people are sceptical about acrylic colour's permanency on fabric, but after extensive trials results have been very satisfactory. As with printing on paper, it is worth making experimental prints onto small, different types of fabric before embarking on a major project.

Previous spread: glass-plate print onto purple paper using firstly red acrylic and then overprinted with gold bronze powder and metallic medium.

Next spread (right): black mica medium and bronze powders, glass-plate printed and inked with turquoise and violet ink.

Next spread (left): black mica medium and bronze powders, glass-plate printed and inked with purple and wine ink on Lokta paper.

Facing page: experimental glass-plate print using teal acrylic, cobalt acrylic and iridescent tinting medium on red cotton fabric.

TIPS

- All fabrics should be prewashed as some have treatments which will prevent adherence of the print.
- Always ensure that the print is adhering to the fabric, especially if the material will require extensive laundering.
- Pin or tape the fabric to a flat or padded surface so that it is stretched and taut. This will help the print to adhere well.
- Some very shiny fabrics do not allow thicker prints to adhere to them. Use a test piece to check the adhesive qualities of a print.
- If the acrylic jar or tube colour is too stiff on the fabric, dilute the colour with an acrylic extender such as acrylic fabric medium. This will make the colour more fluid without reducing its strength.
- Use natural fabrics when printing with bronze powders and metallic fabric medium.
- Further prints can be added to a first print, but beware of smudging – allow each print to dry.

Materials

fabric
one or two glass plates
one or two rollers
acrylic colour (tube or jar)
acrylic fabric medium (optional)
old comb or shaped plastic brush
board or old blanket
pins or masking tape

Method

1 The fabric needs to be held on a padded or hard surface, so first pin it to the blanket, or tape it to a smooth, flat board.

2 Squeeze the required acrylic colours onto a glass plate. Add acrylic fabric medium if required.

3 Mix the colours together and use a roller to spread across the glass plate until it is evenly coated.

4 Draw into the paint to create your design. Use your finger, the comb, or the plastic brush.

5 Place the glass plate inked side downwards onto the fabric and gently press to ensure contact between the printing surface and the fabric. Depending on the fabric's thickness and surface, it may be necessary to press quite hard or to run a clean roller over the back of the glass plate to make a good contact.

6 Lift the glass plate away from the fabric, which if firmly pinned or taped will stay flat, to reveal the contact print.

7 Leave the fabric to dry naturally. It is best to leave it for 48 hours before attempting to wash it.

Note

- Further prints can be made on the same piece of fabric, but this will inevitably thicken the fabric because each print adds a layer of acrylic.

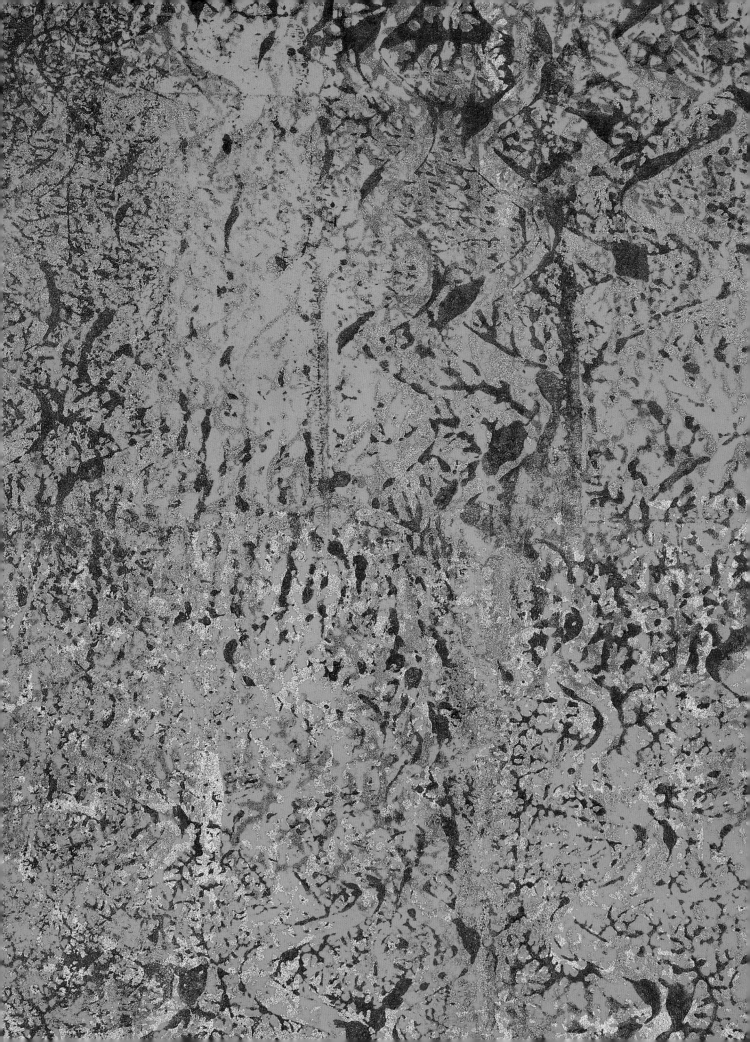

GLASS-PLATE PRINTING ON FABRIC WITH BRONZE POWDERS AND METALLIC FABRIC MEDIUM (ORMALINE)

Remember to wear a mask when mixing bronze powders or to prepare the bronze powders with metallic fabric medium in screw topped jars in advance.

Materials

fabric
one or two glass plates
one or two rollers
bronze powder
metallic fabric medium
old comb or shaped plastic brush
board or old blanket
pins or masking tape
palette knife
mask

Method

1 The fabric needs to be held on a padded or hard surface, so first pin it to the blanket, or tape it to a smooth, flat board.

2 Wearing a mask, put about a tablespoon of metallic fabric medium onto the glass plate that you will be printing from. Add about a teaspoon of bronze powder to the middle of the metallic fabric medium.

3 Using a palette knife, carefully fold the metallic fabric medium over the bronze powder until they are fully mixed. If the bronze powder appears rather grey, add further bronze powder until the mixture has a more metallic appearance.

4 The bronze powder mix is now ready to print directly onto your fabric. Use any of the glass-plate printing methods.

5 Once the fabric print is dry, leave it for 48 hours and heat set with an iron at the highest setting suitable for the fabric.

Further effects

● Try all the techniques outlined for glass-plate printing on paper, including the techniques using two glass plates.

● Remember, mixing acrylic colour with iridescent tinting medium will pearlize the colour. This is excellent for printing onto dark fabrics and especially for printing contrasting colours, such as green onto bright red fabric.

● Acrylic colours can be mixed on the glass plate, giving a variegated effect, or a subtle pearlescent effect when interference colours are added.

● It is possible to print with acrylic and bronze powders and metallic fabric medium on the same fabric. However, the metallic fabric medium needs to be heat-fixed and is designed to be used on a natural fibre.

● If the acrylic or metallic prints are too wet or thick, gently lay a piece of fine paper onto the wet printed surface, lightly rub and lift off the excess colour from the fabric. This will often provide an extra attractive paper print. Many delicate Asian papers are excellent for this purpose.

Facing page: gold and copper bronze powder mixed with metallic fabric medium glass-plate printed onto turquoise cotton poplin which had been dyed with Procion dye. The fabric was further printed with teal acrylic and interference gold.

PRINTING BLOCKS

Blocks of all kinds have been used in producing decorative effects on paper and fabric for centuries. Most people create their first block from a potato at primary school. However unsophisticated a block is, it immediately helps to speed up the process of printing and enables one to produce a comparatively consistent repeating pattern.

Blocks can be produced from wood, metal, lino, card, string and card, and glue and card, as well as from potatoes and other vegetables (although these have a limited life!). The following are required of a printing block, no matter what material it is made of:

- The block must have a raised surface, which must be rigid enough to stay positioned when pressed.
- The surface of the block must be able temporarily to accept the printing ink, but must also be able to release it when pressed against the item being printed.
- The block needs to be made of materials that can be manipulated and drawn to whatever pattern is required.

Collection of blocks that have been made from board, lino, string and found objects. Some of these blocks have been used to print pieces for this book.

MAKING A SIMPLE BLOCK

A card and string block is easy to make, and very effective. Kappa board is used by model makers and exhibition stand builders and can be obtained from craft shops. Make sure the card you choose is rigid, firm and quite thick as it is the part of the block that is held when printing. The card or base needs to be cut to the size of your design.

Materials

firm card, Polyboard or Kappa board
double-sided sticky tape
medium-thickness string
scissors
black/brown pencil or pen
acrylic varnish

Method

1 Draw your design onto the board or card with a dark pencil or pen.
2 Cover the same face of the board or card with double-sided sticky tape. Then peel off the backing paper, leaving the sticky surface exposed.
3 Starting in the middle of the design, place the string onto the sticky tape on top of your drawn line. Tightly twist the string before

BLOCK PRINTING WITH ACRYLIC COLOUR AND BRONZE POWDERS

Materials

fabric or paper

glass plate

two rollers

printing block

acrylic colour (jar)

bronze powder

metallic fabric medium

Left: dark green fabric, block printed using light gold and fire copper bronze powders, metallic fabric medium, interference blue, and purple acrylic.

Method

1 Prepare the paper or fabric for printing. A thin layer of padding beneath these items will help to make a good print. This can be a pad of newspaper, an old blanket, or dense foam. It does however need to be flat, and fabric is best pinned or taped tautly.

2 Squeeze out acrylic colour or mix up bronze powder and medium onto the glass plate as previously described (see page 58).

3 Roll the colour across the plate until the roller is thickly and evenly covered with the acrylic colour or powder/medium mix.

4 With the block design-side upwards and held firmly on the table, roll the colour onto the printing surface until all the printing areas are thickly covered.

5 Quickly place the inked printing block face down onto the paper or fabric. Holding it firmly so that it does not move, run a clean roller over the back of the block, gently pressing to ensure good contact.

6 Peel back the block, move, and repeat the process.

7 Once printing is finished, wipe excess printing colour off the block and leave the paper or fabric to dry. There is no need to wash the block, as dried colour does not affect the following print unless the layers of colour are

you place it so it does not flatten when pressed. Use string to fill in the areas that you wish to print, and make sure it does not cross itself as this will give an uneven surface and it will tend to come unstuck.

4 Once the string is in the desired position, press it firmly with your fingers to ensure good adhesion. Make sure that the ends of the string are firmly attached.

5 Large areas of exposed sticky tape may cause problems when printing. These may need to be cut away or painted with acrylic to prevent them from sticking to the paper or fabric.

6 To make the block more durable, apply a coat of acrylic varnish. This makes the areas of exposed sticky tape less troublesome.

TIP

A piece of shiny thick card or thick felt can be used as a substitute for the string, remembering that it must be the same depth as the string.

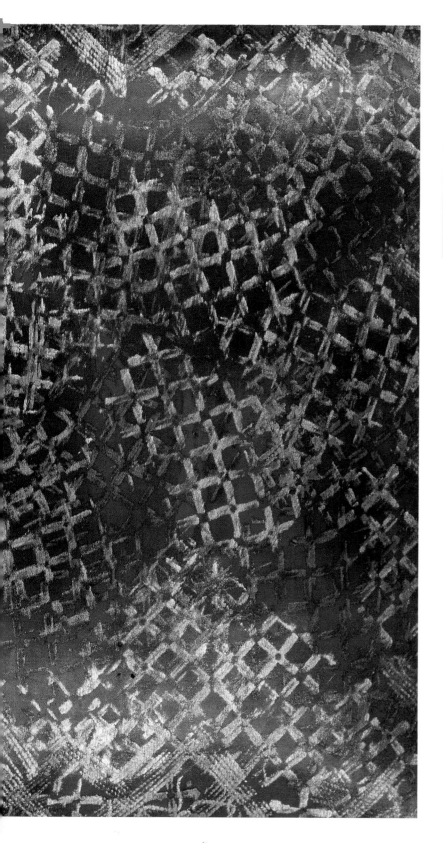

allowed to get very thick, then the quality of the block changes and the print becomes less precise. The lamination of a series of colours does however help to strengthen the block and finally create an attractive item in its own right.

Further effects

- Apply more than one colour to the block.
- Lay the paper on top of the inked block, and run a roller across the surface. This will collect ink from between the lines of string and create a different effect, especially if the paper is a fine variety.
- Make more than one block for your design, filling different areas with the string so that different colours can be printed in different areas.
- Make a series of basic blocks of stripes, circles, or lines, or use random textures, like vermicelli, to fill in areas and create background texture and pattern.
- Make blocks out of 'found' objects (e.g. plastic grids, such as tile spacers, rings, washers, etc.). Most items will make attractive surfaces and patterns.
- Make blocks from open-meshed fabrics, such as heavy manufactured lace.
- Try using traditional Indian wooden blocks. These are strong and quite heavy to print with, so make sure your printing surface is well padded.

USING BLOCKS FOR RUBBINGS

Having created a collection of blocks for printing, you'll soon find that they are also excellent for making rubbings on paper and fabric.

RUBBINGS ON PAPER

Materials

assorted, especially lighter-weight, papers
soft oil pastels or Markal Paintstiks
printing blocks

Method

1 Place a sheet of paper on top of your chosen block, holding both block and paper firm. Then, gently rub the oil pastel across the paper until the desired effect is obtained.
2 Repeat with different colours and different blocks to build a patterned surface.

TIP

When selecting paper to decorate, bear in mind that finer papers will be more sensitive for rubbings but will easily tear.

Facing page: viscose satin was dyed and painted cerise and purple, and then iridescent blue, turquoise and silver Markal Paintstik was rubbed over a block made from commercial tile spacers and string.

Right: dark red fine Indian craft paper laid over a lino block and rubbed with iridescent blue Markal Paintstik.

RUBBINGS ON FABRIC

Materials
assorted fabrics
Markal Paintstiks
printing block
masking tape

Method
1 Tape the ironed fabric by one edge to a table or firm board.
2 Select your first Markal colour and cut away the protective cover from the end of the stick to reveal the soft colour.
3 Select the block to pattern your fabric, and carefully place this under the fabric where the pattern is required. Holding the block and fabric firmly, gently rub the Paintstik across the surface of the fabric, thus revealing the block pattern from underneath. Do not layer too much of the colour from the Paintstik onto the fabric or it will lose its intrinsic quality.
4 Move the block and repeat step 3 to pattern the fabric, adding whatever colours you require.
5 When the rubbing is completed, leave the fabric for 48 hours to absorb the colour and for the oil to evaporate. Iron the fabric for four minutes using the correct setting for the fabric. The fabric is then ready for laundering and use.

Further effects
● Make blocks of delicate textures (e.g. fine crocheted lace). It is surprising how delicate a pattern can be rubbed through a lightweight fabric.
● Use off-cuts of textured, raised pattern wallpaper, selecting different areas to create your own design with other prepared patterns.
● Make a collection of textured papers, cards and wrappings used for everyday household items, such as bubblepack or the bubbled polystyrene carton bases used for takeaways. These can provide a wealth of ready-made patterns.
● Try using patterns within limited areas of the fabric rather than all over (see the section on masks on pages 80-83).

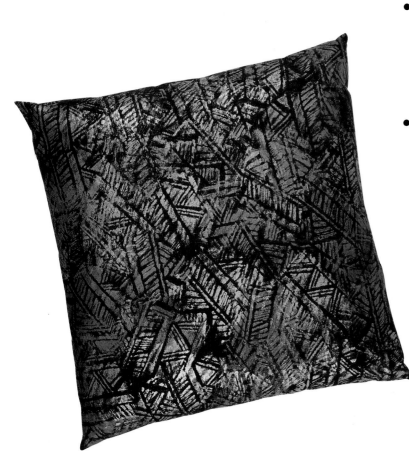

Cushion decorated with gold, iridescent brown and copper Markal, rubbed over a lino block placed under black fabric.

ROLLER PRINTING

When using a roller to ink a glass plate, the print colour will often coat the roller unevenly. This can be used directly onto fabric or paper. Roller techniques are very useful when working with masks and stencils (see page 80).

USING A ROLLER

Materials

fabric or paper
glass plate
acrylic colour (tube or jar)
rollers

Method

1 Prepare the fabric or paper for printing as before by securing it to newspaper, an old blanket, or to a board.
2 Squeeze a small quantity of acrylic colour onto one end of a glass plate, to the width of your roller. Lightly roll the colour across the glass plate so that the roller is coated quite thickly. If the roller does not rotate, try a very light pressure, barely touching the acrylic.
3 Roll the surface of the acrylic colour so that the colour is tacky. This will create a ridged surface on the roller. With care, this can be transferred to paper or fabric – make sure you hardly touch the printing surface with the roller – to print lines or rivulets of colour that can make attractive patterns and textures on papers or fabrics.
4 Leave the paper or fabric to dry.

Further effects

● Ink two glass plates, place them together, and separate them to reveal the organic pattern.

Viscose satin dyed in tan Procion, block printed with acrylic colour mixed with fabric medium and iridescent tinting medium. Further colour was applied using roller printing and acrylic colour.

If the roller is then taken across the inked surface, it will pick up a different, linear, ridged pattern that will create branches of lines.

● If the printing colour is thick when the roller is taken across the block, and if it is pressed hard, the roller will be left with the impression of the block pattern. This is usually the negative area of the block (i.e. the non-raised areas). With care, this can be transferred to both paper and fabric, making interesting alternatives to the actual block print effect.

● When taking the roller across a block to make a roller print, it is also possible to distort or alter this print. Take the roller across the block at an angle, or slide the roller momentarily so that the pattern is not a true negative of the block. This can be effective when carefully printed in selected areas.

TIP

This technique is easy when acrylic colour has a thickener added, such as heavy gel medium. It will print well with bronze powders and metallic fabric medium and it is particularly effective on a dark background using acrylic interference colours.

Next spread (left): ultramarine, yellow and red acrylic, mixed with heavy gel medium and applied with a roller to green and red Lokta paper.

Next spread (right): interference acrylic colours and various bronze powders, with metallic fabric medium, applied with a roller to a piece of viscose satin which has been dyed in Procion dye.

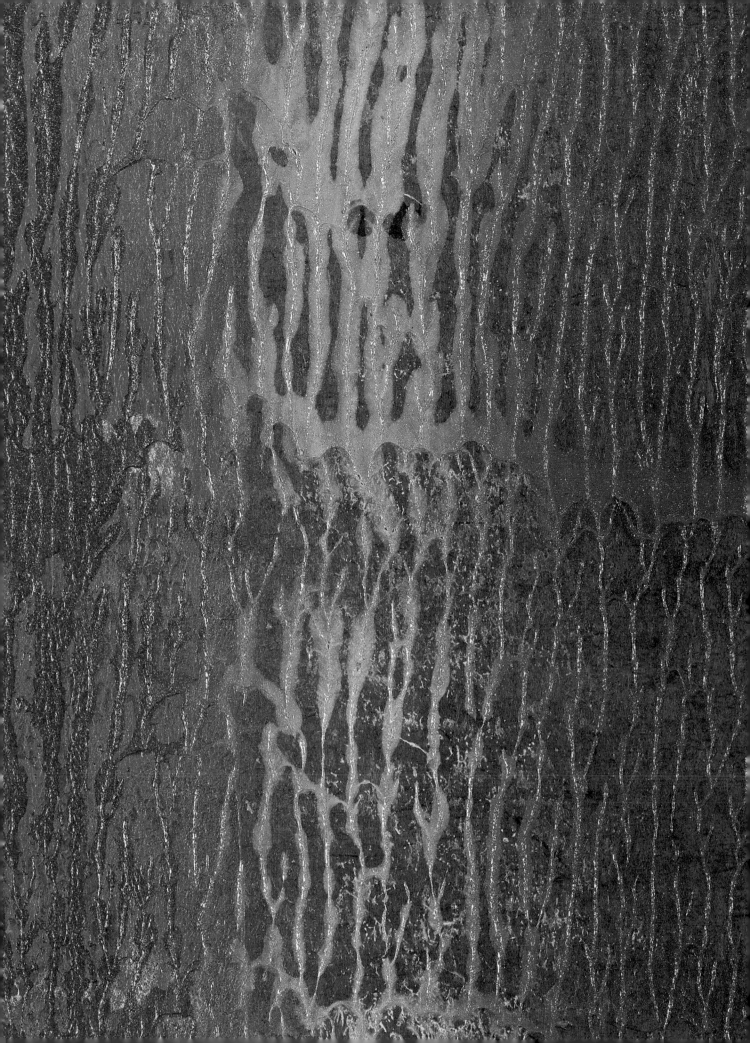

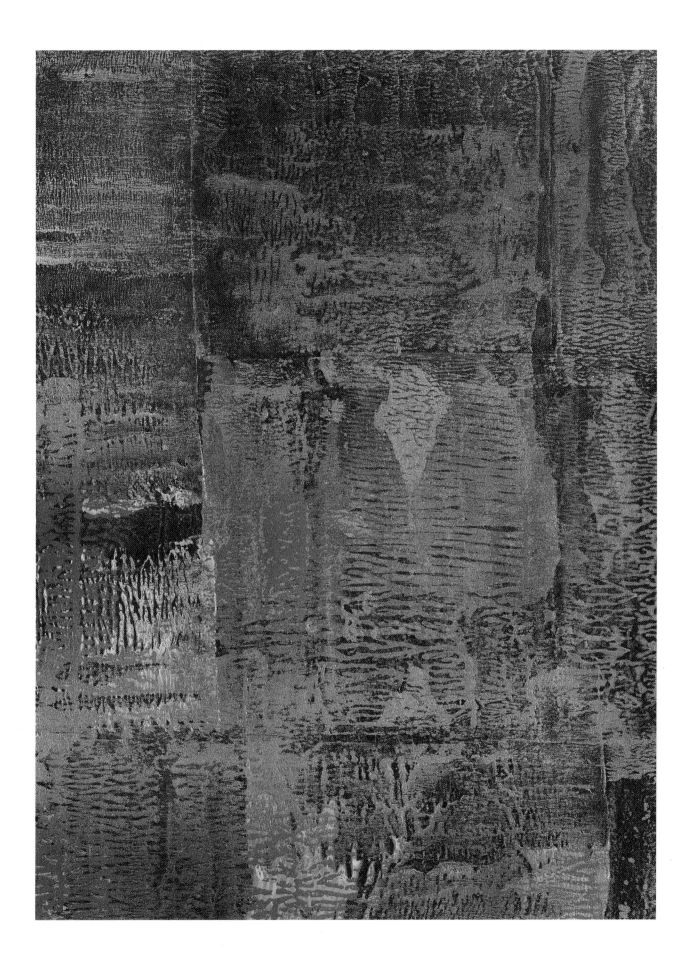

MASKS AND STENCILS

hen designing a print or working out an idea for a design on paper or fabric, there are often areas where printed colour or patterning are not required. If so, you will need to mask your work.

Masks can be simple or complicated, from a piece of paper placed temporarily over a specific area, to a very intricate and complex cut mask intended to keep an area clean and clearly defined. Masks on paper can be tricky, as sticking something to the paper can damage its surface. Spray mount or masking fluid are useful aids.

MASKING TAPE

This excellent tape is readily available in a number of widths. It is also flexible enough to be tensioned to make curves as well as straight lines. When printing with acrylic and bronze powders, good quality masking tape does not allow seepage, and will therefore produce a crisp finished line. Fabrics can be taped with intricate grids, parallel lines, borders and areas that can then be decorated with any of the printing methods already explored. Areas within the masks can be printed and then later further embellished with Markal Paintstiks (see page 43).

Masking tape can be carefully lifted during printing, once a printed coat is dry, and reapplied to alter very slightly the emphasis of an area or the design.

STICKY-BACKED PLASTIC (FABLON)

This can be cut into quite intricate patterns and then applied to fabric as a mask. When cutting the design, use both the positive and negative areas (i.e. the cut and uncut areas), which will help to provide continuity of design within a piece of work.

USE OF MASKS AND STENCILS WITH MARKAL PAINTSTIKS

Materials

fabric (natural or synthetic)
Markal Paintstiks
sticky-backed plastic (Fablon)
toothbrushes (one for each colour)
craft knife
cutting mat
masking tape

Method

1 Before cutting out the sticky-backed plastic, draw the design onto its backing paper. Remember this will be in reverse.

2 Place the sticky-backed plastic face down onto a cutting mat and secure with masking tape.

3 Using a fine craft knife, carefully cut out the design. Make sure that all lines are smooth with no erratic cuts as these will show when the fabric is printed. At first it is advisable not to make the pattern too intricate or fine as this makes the plastic prone to curling up when you remove its backing, and therefore more likely to stick to itself. So initially cut a simple pattern and then progress to more complex and detailed pieces.

4 Prepare the fabric as before by stretching it onto a printing top or board.

5 Carefully begin to peel the backing away from the plastic. Start at one corner, sticking it to the fabric, and gradually work your way across the fabric until the mask is attached. Any areas that are not quite correct can be repaired with small pieces of masking tape. Your mask is now ready for printing or for use with Markal.

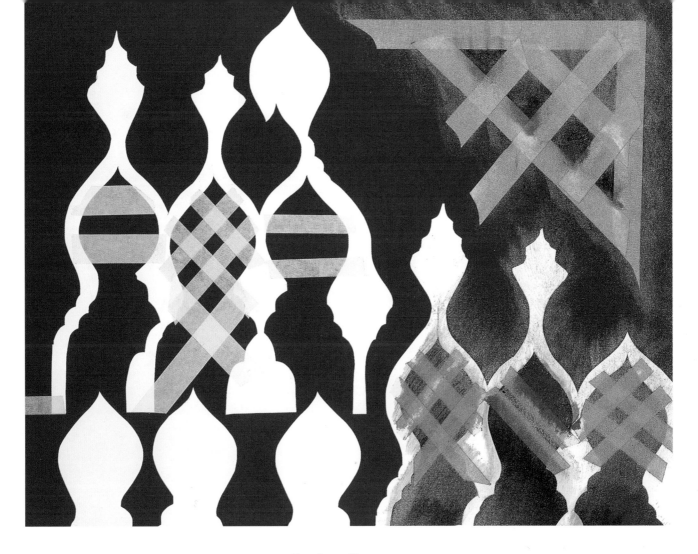

6 Select a Markal Paintstik and carefully slice the protective skin from the end of the stick. Rub the colour along the edge of the first area to be coloured, keeping the colour on the stencil (i.e. apply a coat of Markal to a section of the stencil).

7 Take a toothbrush and brush the colour off the stencil onto the surface of the fabric. Brush the toothbrush away from you so that the mask does not get torn and the colour is even.

8 Continue applying colour to the stencil and brushing it onto the fabric to the required density. Further colours may be added, either beside the first colour or blended with it.

9 As soon as all the areas of colour have been completed, the stencil can be removed. Allow the Paintstik to be absorbed into the fabric for at least 48 hours. Colours will not smudge when removing the mask unless the Markal area of fabric is rubbed.

Further effects

- A torn-paper mask can be very effective when used with Paintstiks, as the soft quality of the colour will register all the fine tears on the paper's edge.
- Rubbing a Paintstik directly onto fabric can be very effective. But take care not to apply it too thickly as this will stiffen the fabric and can prevent the colour from adhering to its surface.

TIP

Use the same technique with strips of masking tape, building up the Markal colour with toothbrushes to obtain solid areas of colour.

Red fabric in the process of having gold, iridescent blue and turquoise Markal applied. Both cut sticky-backed plastic masks and masking tape are used here.

Above: purple fabric prepared with sticky-backed plastic heart shapes for glass-plate printing.

Facing page: purple-dyed fabric, glass-plate printed using gold and copper bronze powders, pearl lustre powders with metallic fabric medium. The plain purple hearts are where the sticky-backed plastic masks were placed.

MASKS AND STENCILS WITH ACRYLIC OR BRONZE POWDERS AND METALLIC FABRIC MEDIUM

Materials

fabric

stencil or mask made of sticky-backed plastic

acrylic colour (tube or jar)

bronze powders

metallic fabric medium

glass plates

rollers

palette knife or printing block (depending on which method is selected)

Method

1 Stretch the fabric onto a board, or pin it tautly to a padded surface.

2 Stick the stencil to the fabric as described in the previous method.

3 Prepare the glass plate for printing with a roller or glass plate, and prepare acrylic colour or bronze powders and metallic fabric medium as previously described (see page 66).

4 Select an unmasked area and proceed with the printing method chosen. Remember that the glass plate may not exactly fit the printing area. This can be remedied either by using a temporary paper mask or by wiping a part of the glass plate clean.

5 Complete all areas with colour before removing the stencil.

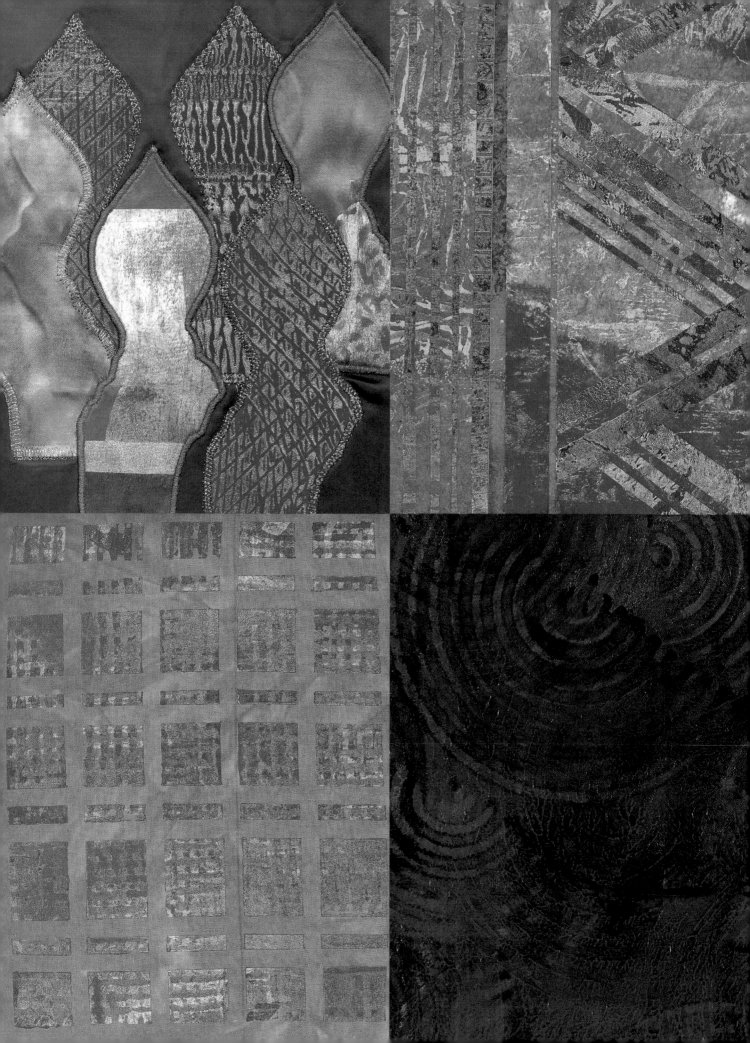

COMBINED TECHNIQUES

This chapter shows how some of the materials and techniques introduced in the two previous chapters can be used in combination to create different printed and dyed fabrics as well as paper collage. Remember that all these techniques can be easily achieved without expensive equipment or vast workshops.

If the paper and fabrics do not turn out how you want, then continue working on them. A fabric can be greatly improved by being put back in a dye bath, or a decorated paper enhanced with ink painted across an acrylic or bronze powder print. Indeed, often the so called 'failures' turn out to become favourites. Even when you have abandoned a piece, you can always cut it up and re-use a section that you like. This book is not intended to stay neatly on the bookshelf – make sure that it is used as often as your favourite cookery book so that it becomes spattered with colour and the pages stick together!

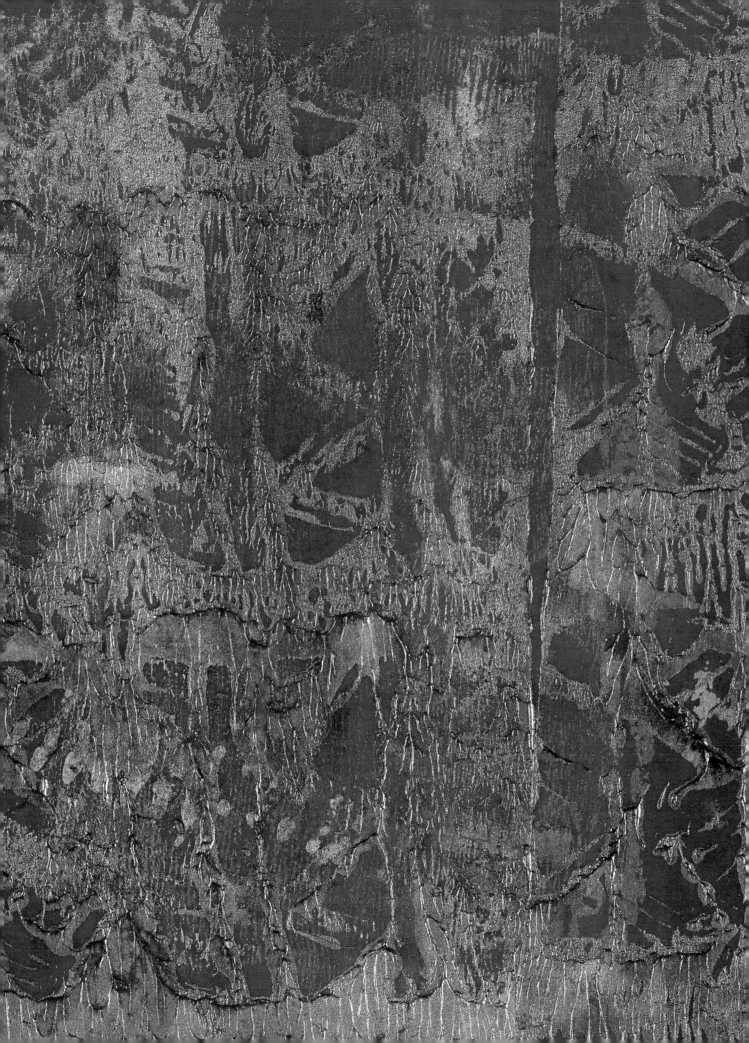

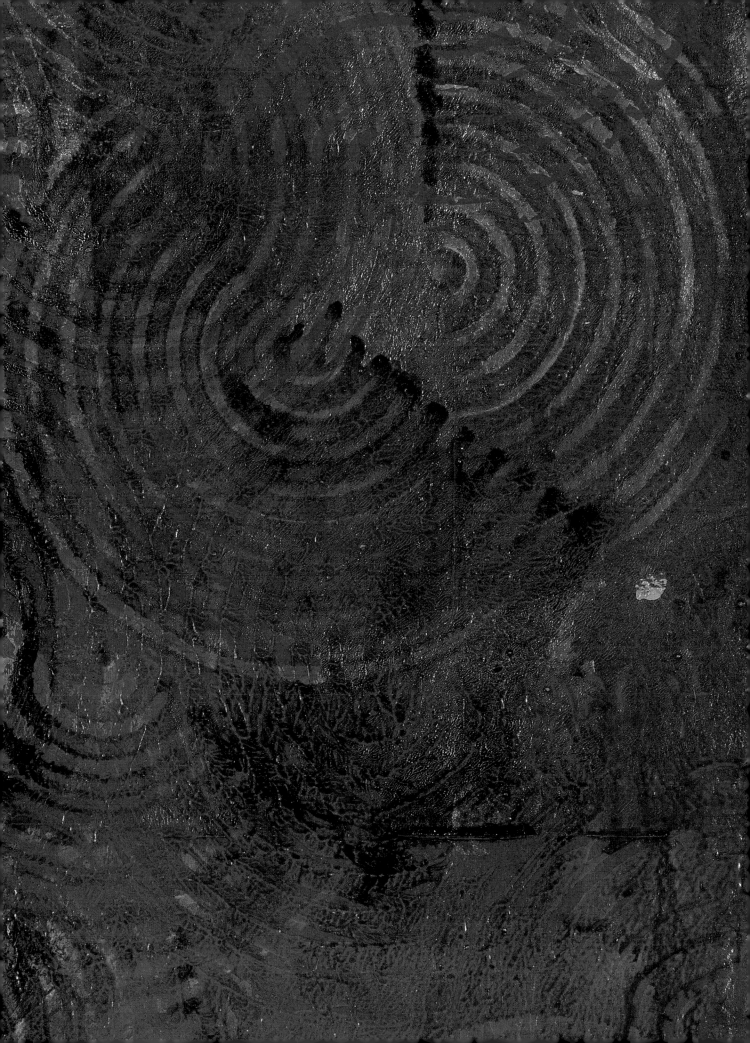

GLASS-PLATE PRINTING ON FABRIC WITH BRONZE POWDERS

This piece of fabric is created using glass-plate printing. A simple pattern was drawn into bronze powders mixed with metallic fabric medium (Ormaline).

Materials

48 sq cm (19 sq in) red cotton fabric

glass plate

roller

bronze powders (orange-gold, silver)

metallic fabric medium (Ormaline)

board or blanket

pins or masking tape

palette knife

mask

ruler or tape measure

old comb, shaped plastic brush or plastic
 tile grouter

newspaper

Method

1 Prewash the fabric, dry, and iron flat. Tape it to a board, or pin it to a blanket. This will help the adhesion of the bronze powder and the quality of the print.

2 Lay some newspaper on the work surface and then collect together the bronze powders, metallic fabric medium, glass plate, roller, palette knife, and mask.

3 Pour out about two tablespoons of the metallic fabric medium on the centre of the glass plate.

4 Put the mask over your nose and mouth to protect against inhalation of the bronze powders, and use the palette knife to mix about a teaspoonful of the orange-gold into the fabric medium. Once fully mixed it should glisten slightly, but a slight bloom as the medium dampens the bronze powder will temporarily take away the shine. When the

bronze powder is fully mixed into the medium it is safe to remove your mask.

5 Spread the bronze powder mixture evenly across the glass plate using the roller. It needs to be an even layer, but it is unwise to have too thick a layer of colour.

6 Quickly draw into the bronze powder and metallic fabric medium mixture with the tile grouter or comb, or use a finger. Keep the design simple: the one illustrated on the facing page is a simple grid, made by drawing the grouting tool both horizontally and vertically across the glass plate. It is necessary to work quickly as the metallic fabric medium tends to re-cover the glass quite rapidly.

7 Once the pattern is drawn, quickly turn the glass plate over and place it onto the fabric, preferably in the centre first. In the print shown the glass plate was set at an angle to avoid too rigid an appearance. Gently press the glass plate to ensure good contact with the fabric.

8 Carefully lift the glass plate from the fabric and place it back on the newspaper. If there is still a reasonable amount of bronze powder and metallic fabric medium left on the plate and the roller, run the roller across the plate again and repeat the process. Place the second print parallel with the edge of the fabric so that it overlaps the first print in the centre of the fabric. Remember to place the glass plate carefully as close to the previous print as possible so that the print becomes an all-over texture of checks, squares and grids.

9 Repeat this last stage three times so that the fabric is covered with an orange-gold print.

10 Using a mask to protect your nose and mouth, mix together the silver bronze powder and metallic fabric medium. Print this four times around the edge of the fabric, this time angling the print around the centre, so that it overlaps at the edge of the fabric.

Previous spread (left): gold bronze powder mixed with heavy gel medium printed off a roller which had been taken across a lino block. Once the heavy gel medium had dried the Lokta paper was painted with wine-red Procion dye.

Previous spread (right): wool Indian rag paper was originally glass-plate printed with red acrylic. The paper was further painted with acrylic gloss varnish, which was drawn into with a tile grouter before it dried.

Facing page: initial glass-plate print using orange gold bronze powder and metallic fabric medium on red fabric. The glass plate was drawn on with a tile-grouting tool which gives an evenly spaced pattern, but the method makes for a more random effect.

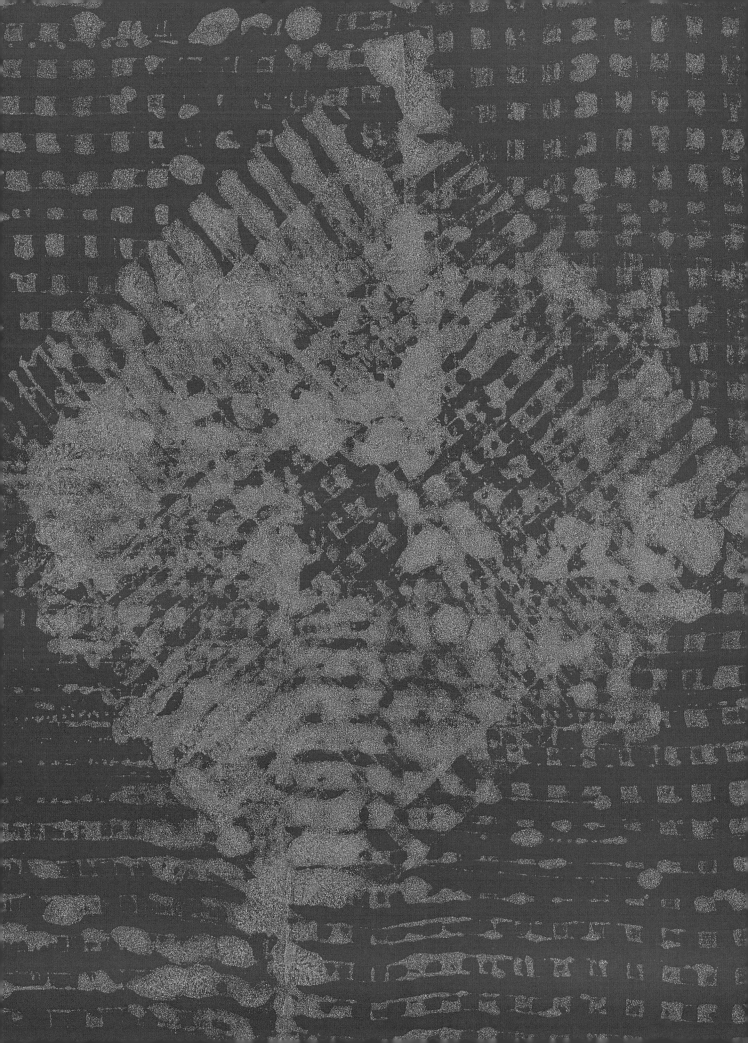

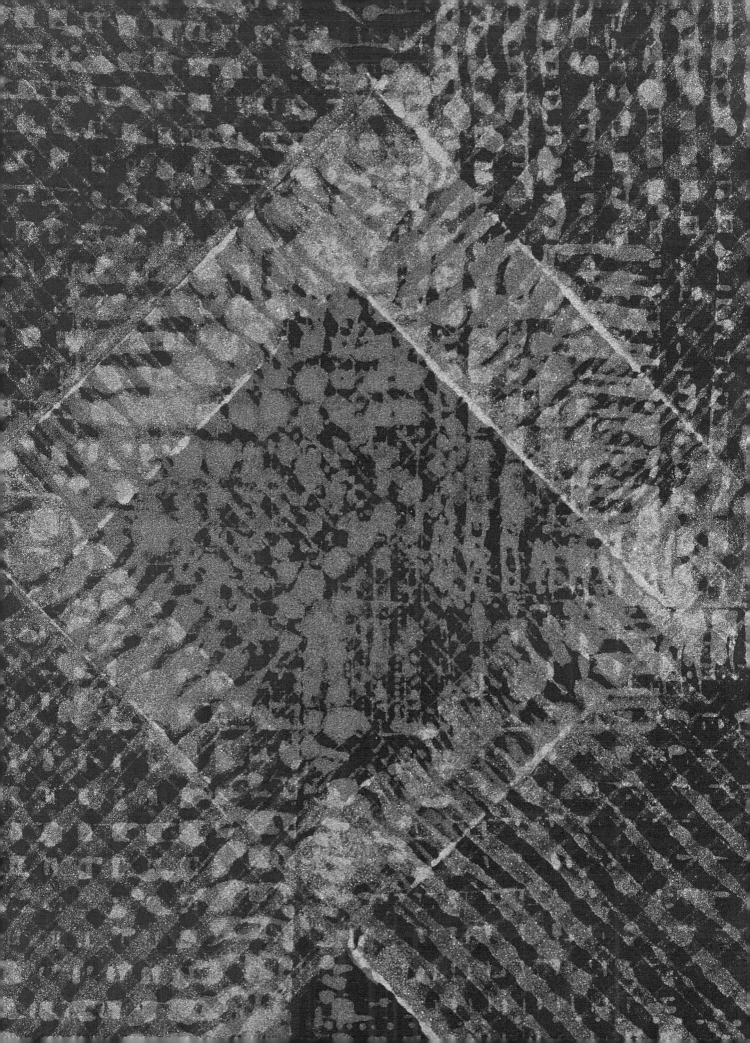

11 Leave to fix for 48 hours, then remove the fabric from the padding or board, and thoroughly iron the printed area to make the metallic powders permanent. Printed metallic powders can be gently hand washed.

Note

● If, when you are printing, the bronze powders and metallic fabric medium appear too thick or wet on the fabric, carefully lay an absorbent piece of paper on top of the print and gently press it to remove the excess colour from the surface of the fabric (in itself this creates an attractive piece of paper).

● Remember that glass-plate printing, by its nature, does not give a perfect repeat pattern: no two prints will be identical. This gives variety and unexpected qualities to the work.

● Do not print too many layers of bronze powder and metallic fabric medium as this can make the fabric very stiff and sometimes almost sticky.

● Remember to wash up any equipment as soon as possible, as the metallic fabric medium does tend to have good adhesion qualities.

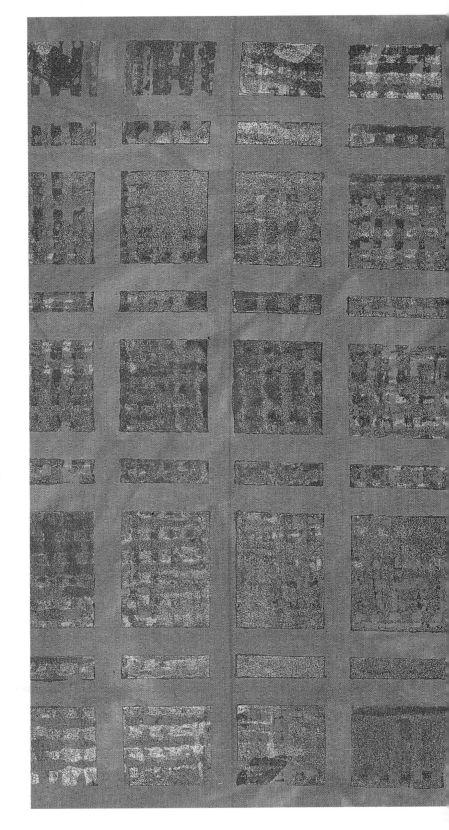

Right: cotton fabric printed using glass plates and bronze powders over fabric which had been masked with masking tape.

Facing page: previously printed fabric with further glass-plate printing using silver bronze powder and metallic fabric medium.

PAINTSTIKS, MASKS AND PRINTING BLOCKS ON FABRIC

This attractive fabric was created using Markal Paintstiks, printing blocks, and simple masking methods. To make a similar piece you will need to choose a dark, medium-weight fabric of any fibre but with a matt surface. The fabric shown was decorated using iridescent turquoise, bronze, and gold Markal Paintstiks; choose your own selection of colours, but iridescent colours show up well on dark fabric and so the results are particularly effective.

Materials

prewashed dark fabric (51 sq cm/20 sq in) for
 a cushion front
flat piece of hardboard, slightly larger than fabric
Markal Paintstiks
toothbrushes (one for each colour)
2.5 cm (1 in) wide masking tape
ruler or tape measure
white pencil or tailor's chalk

For the printing block:
stout cardboard
textured lace (e.g. crochet)
double-sided sticky tape
scissors

Method

Preparation of fabric:

1 Find the centre point of the fabric and mark out a 46 cm (18 in) square from this point with a white pencil or tailor's chalk.
2 Carefully tape the fabric to the smooth side of the board, taping three sides only and making sure it is square.
3 Mark the centre point of the fabric on each of the four edges.
4 Measure and mark 5 cm (2 in) from either side of this mark on two opposite fabric edges.

5 Take two lengths of masking tape, each equivalent in length to the width of the fabric, and stick them across the fabric from these marked points, making sure the tape is at right angles to the edge and that the two pieces of tape are parallel. You should now have a 10 cm (4 in) band across the middle of the fabric, between the two lengths of tape.
6 From the outer edge of these pieces of masking tape, measure a further 10 cm (4 in) and stick two more pieces of tape down. The fabric will now have three parallel bands, with a narrow border area at each edge.
7 Turn the board through 90 degrees and repeat the process of applying tapes across the fabric, this time creating squares. Each should be 10 cm (4 in) square, and there should be at least a 5 cm (2 in) border on the outer edge.

Preparation of printing block:

1 Cut a 10 cm (4 in) square of stout cardboard.
2 Cover one face of the board with double-sided sticky tape and remove the top paper so that the whole of the surface is sticky.
3 Cut a piece of textured lace to fit the block and press it onto the tape. Make sure it is well adhered.

To colour your fabric with Markal:

1 Slide the block under the fabric, placing it under one of the squares between the tapes. Start in a square on the far side of the board.
2 Select a Markal Paintstik and carefully remove the protective skin with a sharp knife. Make sure that this piece is discarded.
3 Hold the block still and rub the Paintstik across the surface of the fabric until the pattern or texture of the lace is evident on the fabric. Make sure that you do not rub too heavily or you will smudge the image, it just needs to be hard enough to define the pattern.

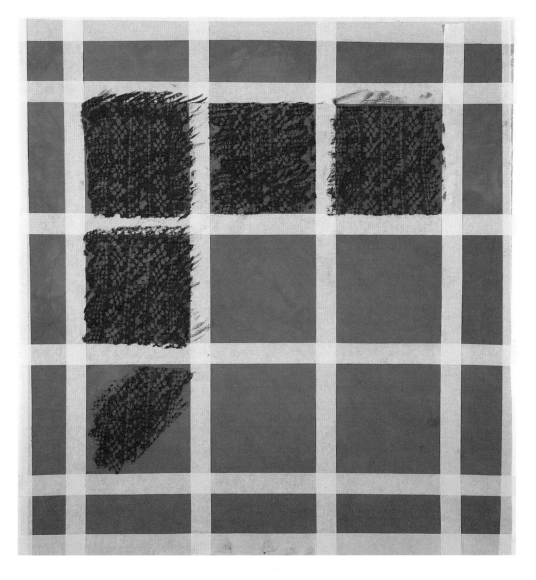

Cotton fabric dyed with teal Procion dye, taped to a board, and divided with masking tape ready for the application of Markal. The block has been made using a piece of board with crochet lace stuck to it.

4 Repeat this rubbing on all the squares, using the same colour, or varying the colours, or mixing and blending them, depending on the effect required.

5 Finally, remove the block and rub a Paintstik directly onto the fabric between the masking tape around the edge. Use a toothbrush to brush this onto the fabric in the narrow border area.

6 Once the fabric is complete, leave it for 48 hours on the board with the masking tape in place.

Finishing the Fabric

1 After 48 hours the Markal colour should have been absorbed into the fabric and should not be greasy to touch. You can now remove the masking tape.

2 Iron the fabric right side up for at least four minutes, with the iron at a suitable setting for the particular fibre. The heat will fix the colour to the fabric. The fabric can then be washed, if this is required, either by hand or in a washing machine.

Above right: gold, iridescent bronze and purple Markal have been used to rub the design from the prepared block which was under the fabric. The iridescent purple, bronze and gold are applied with a toothbrush from the masking tape around the edge of the fabric.

Below right: completed fabric with nearly all the masks removed ready to be ironed and washed before making up.

USING DECORATED PAPERS

This design was created using a selection of printed and decorated papers. The inspiration for this piece was African pottery and patterns drawn on African buildings. Various patterns were selected, interpreted in strips and then amalgamated to create the finished piece. The nature of the printing and decoration methods used means that it is not possible to recreate exact effects with paper collage. Working on a paper collage with care and sensitivity is an exciting and rewarding way to use a variety of the lovely papers available.

Materials

a selection of papers in various thicknesses that have been printed or inked (it may be advisable to select a limited colour range)
sheets of plain coloured paper (matching or complementing the colours chosen)
a sheet of firm cartridge on which to glue the final design
craft knife
cutting mat or board
PVA glue

Method

1 Start with simple shapes for your patterns, such as triangles and strips. Carefully select the printed areas of the papers that are to be used. Cut a window or template in a piece of card to help select which areas of the paper are most suitable.

2 This design is made in rows. The left-hand row has a background of fine Lokta paper printed with gold bronze powder and black acrylic. The triangles and strips have been cut from a heavy weight Lokta paper which has been block printed with gold acrylic and inked with red and yellow before being glued into place. This paper is used again for the right-hand row.

3 The second row uses another piece of coloured Lokta paper, glass-plate printed using yellow and orange acrylic. This piece of paper is then glued onto a straight strip of cartridge paper to give structure and depth to the composition.

4 The third row has three layers: the first is on cartridge paper which is roller-printed with scarlet and yellow acrylic. The second layer is made of a strip of bronze powder-printed Indian cotton rag paper which has had red ink applied. The third layer is made with cut strips of coloured and printed Lokta paper, woven together into a trellis-like arrangement. It is glued into position on top of the previous layers with any uneven edges trimmed away.

5 The fourth row uses two layers of paper. The background is another piece of the dyed and printed Indian cotton rag paper. Strips of printed blue paper are glued on this, taking care to keep the pattern in order while spacing the strips out.

6 The last row is similar to the left-hand row except that this time thin Lokta paper is glued onto the heavier inked and printed Lokta paper. The fine Lokta paper has been printed with turquoise acrylic, overprinted with green interference acrylic and then inked with turquoise colour.

7 The strips of pattern are arranged together and laid onto contrasting and complementing pieces of paper until the piece looks complete.

8 Finally, glue all the strips and background onto a large piece of cartridge paper to make the whole artwork stable.

Working in this way enables wide experimentation with areas of pattern, paper and print. Even when cutting the papers to try ideas, you can often glue the paper together again if you are not satisfied with the result.

Next spread: collage influenced by designs drawn into the clay of African pottery. Printed and painted papers were cut, woven, and laid on top of each other to create a strong and vibrant effect.

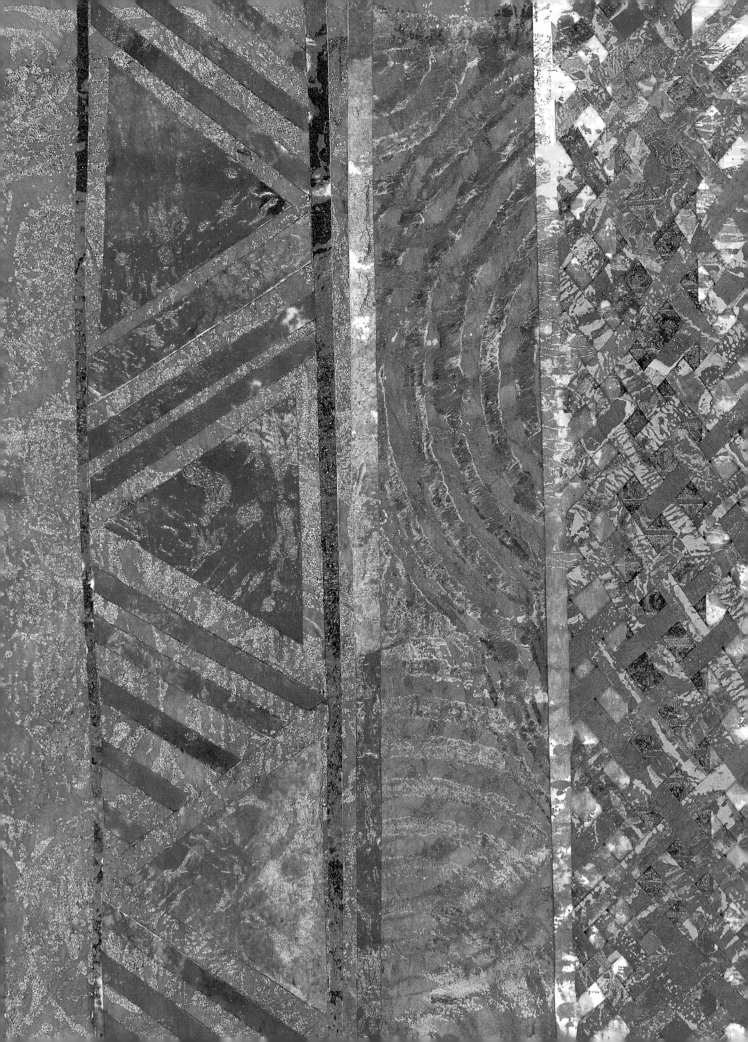

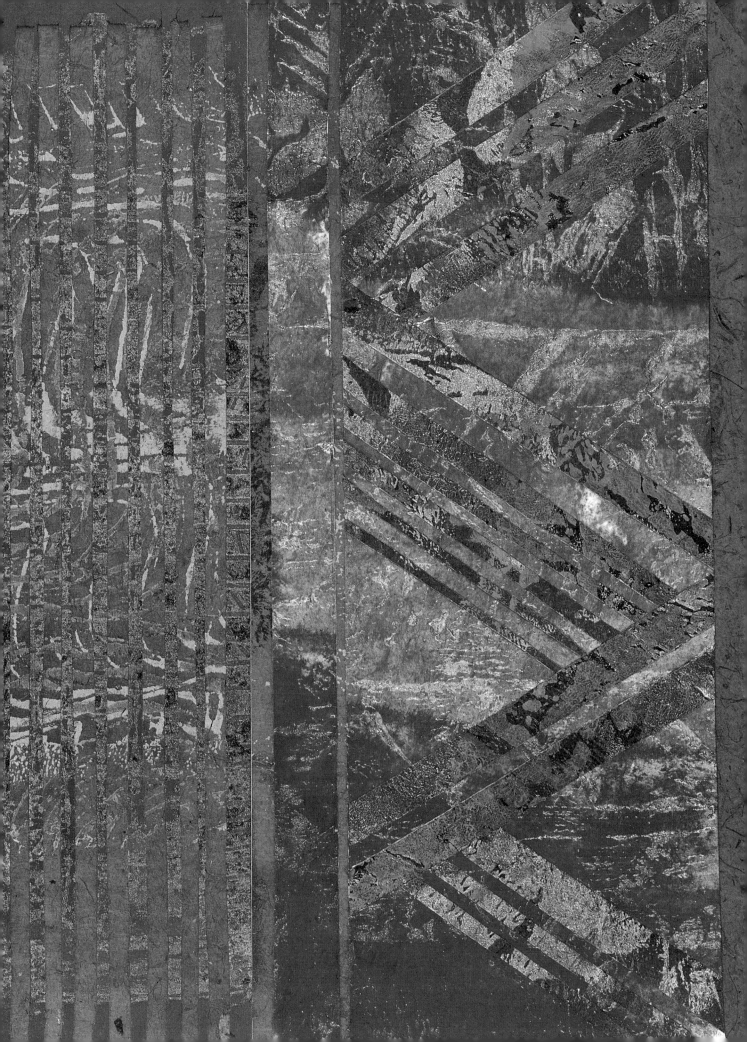

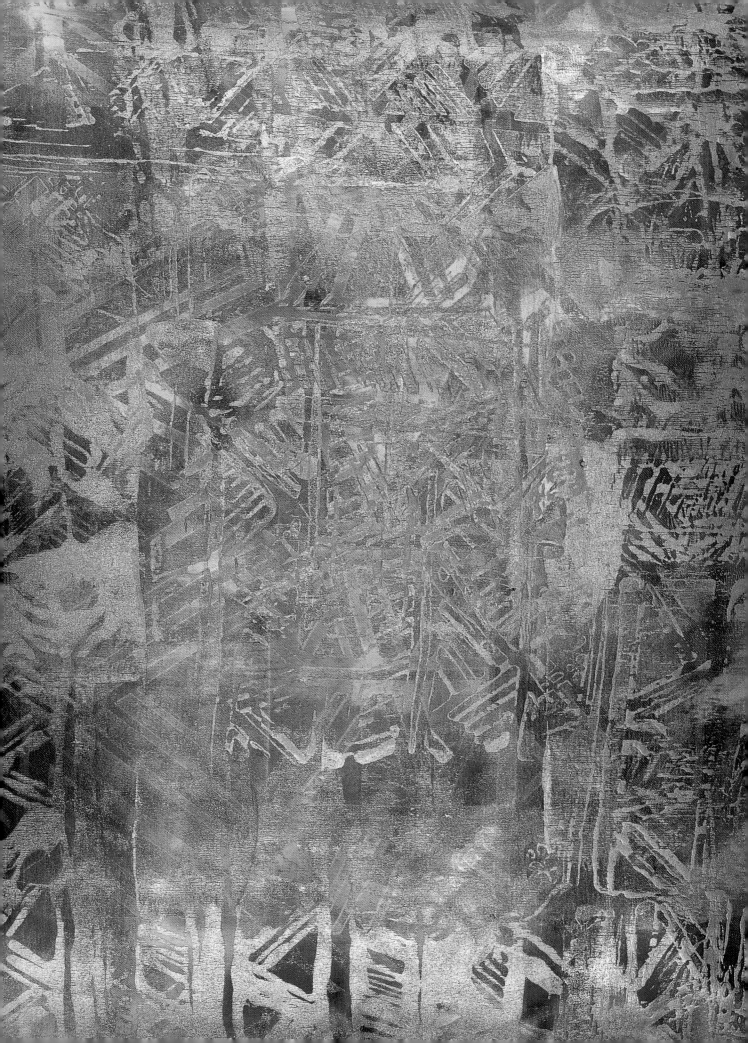

ACRYLIC, PAINTSTIKS AND GLASS-PLATE PRINTING ON FABRIC

The fabric illustrated on pages 100–101 was produced using two separate techniques: glass-plate printing with acrylic colour, followed by the addition of professional coloured Markal Paintstiks. The yellow fabric used is a commercially produced polyester cotton, chosen to contrast with the bold acrylic colours and the Markal Paintstiks. Instead of a plastic tile grouter, you could use a piece of stout card cut with grooves to act as a fat comb.

Materials

approx 46 cm (18 in) square brightly coloured
 fabric for a cushion front
board or padded surface
glass plate (approx A4 size)
roller
1 cm (½ in) and 2.5 cm (1 in) masking tape
acrylic colour (scarlet, cobalt blue and Christmas
 green)
Markal Paintstiks (naphthol crimson, orange and
 cobalt blue)
toothbrushes (one for each colour)
plastic tile grouter

Method

1 Tape the fabric square to the board or padded surface.
2 Find the centre of the fabric and mark out a 40 cm (16 in) square using 2.5 cm (1 in) wide masking tape. This marks your finished edge.

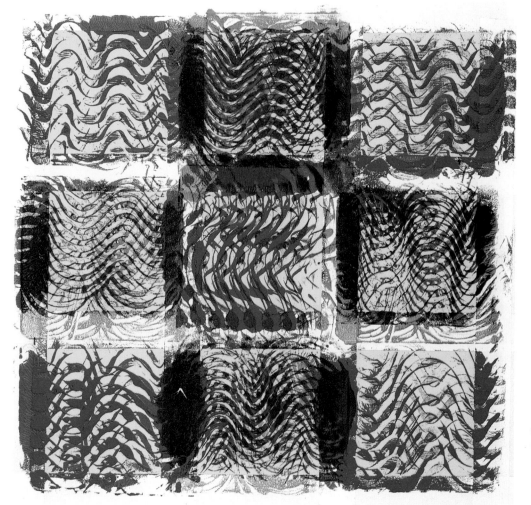

First stage of print on yellow polyester-cotton fabric, masked and glass-printed using scarlet, cobalt blue, and Christmas green acrylic.

Facing page: viscose satin, dyed and painted with a range of Procion colours, block printed and roller printed with gold bronze powders and interference acrylics.

3 Divide the fabric into nine squares by the following method. Lay a strip of 2.5 cm (1 in) masking tape down the left-hand edge of the fabric, within the 40 cm (16 in) square. Then measure a 10 cm (4 in) space and apply a further strip of 2.5 cm (1 in) masking tape. Continue across the fabric until three parallel bands run down the fabric. Then turn the fabric through 90 degrees and repeat the process to produce nine 10 cm (4 in) squares.

4 Roller a small amount of scarlet acrylic onto the glass plate. When the glass plate has an area about 10 cm (4 in) square inked, draw into the acrylic with the tile grouting tool. Make a simple wavy pattern.

5 Print the pattern into the squares marked on the fabric. Depending on the thickness of the acrylic, press the plate gently onto the surface of the fabric. If it does not print well, print again, being aware of the amount of acrylic needed on the glass plate and the amount of pressure required.

6 When all nine squares have been printed, leave the fabric to dry and clean the glass plate and roller.

7 Repeat the process with cobalt blue acrylic, using the same type of pattern so that the patterns have a similar feel and work together within the squares. Leave to dry.

8 Finally, add Christmas green in the five central squares. Do not panic if the fabric looks rather

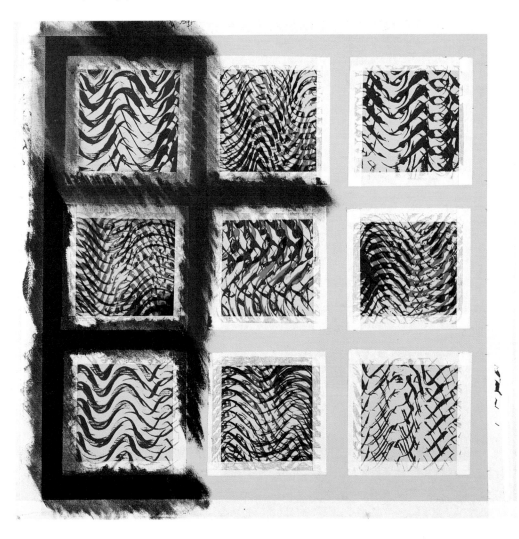

The second stage of the print with the fabric re-masked around the printed areas so that professional Markal colours can be applied directly onto the fabric.

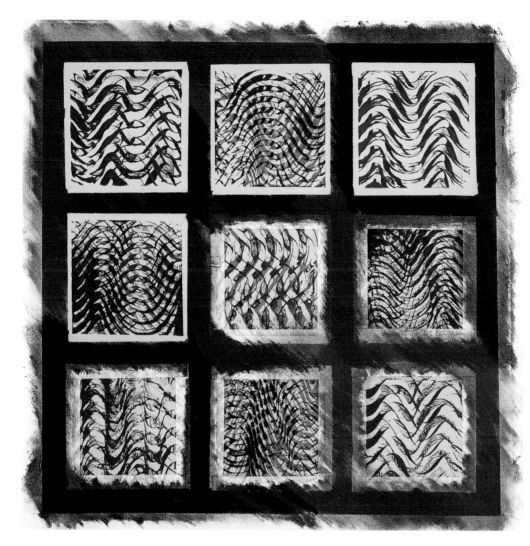

The finished fabric, with most of the masks removed, and the Markal and the glass-plate printing completed.

messy at this stage; removing the masking tape will show how well ordered the design really is.

9 Once the fabric is dry, remove the tape and apply 1 cm (½ in) masking tape parallel with the edge of the printed areas, thus leaving a fine frame of yellow around the printed area.

10 Apply the orange Markal directly onto the fabric in the band between the masking tapes and work it into the fabric with a toothbrush. The Markal can be applied with firm strokes so that there are lines in the colour to contrast with lines in the printed area.

11 Add the naphthol crimson and cobalt blue in the same way, building the colour into broad stripes. Be careful not to mix the orange and cobalt blue as this creates a rather muddy tone.

12 Once the design is complete, leave for 48 hours and then remove the masking tape. Iron the fabric for four minutes under the hottest iron it will take. Make sure the Markal has been fully absorbed into the fabric; when it is thick it sometimes takes longer for the oil to evaporate. If in doubt, cover the fabric with kitchen paper when ironing, or iron on the reverse. The important thing is to apply heat to fix. The fabric is now finished and can be washed if required.

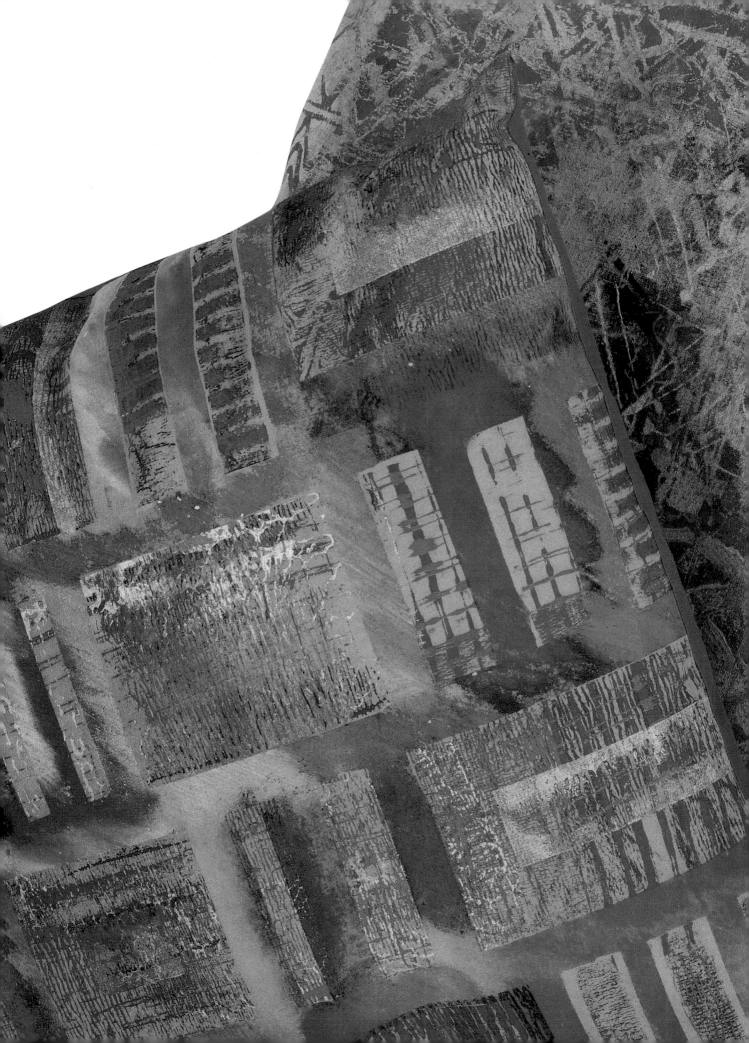

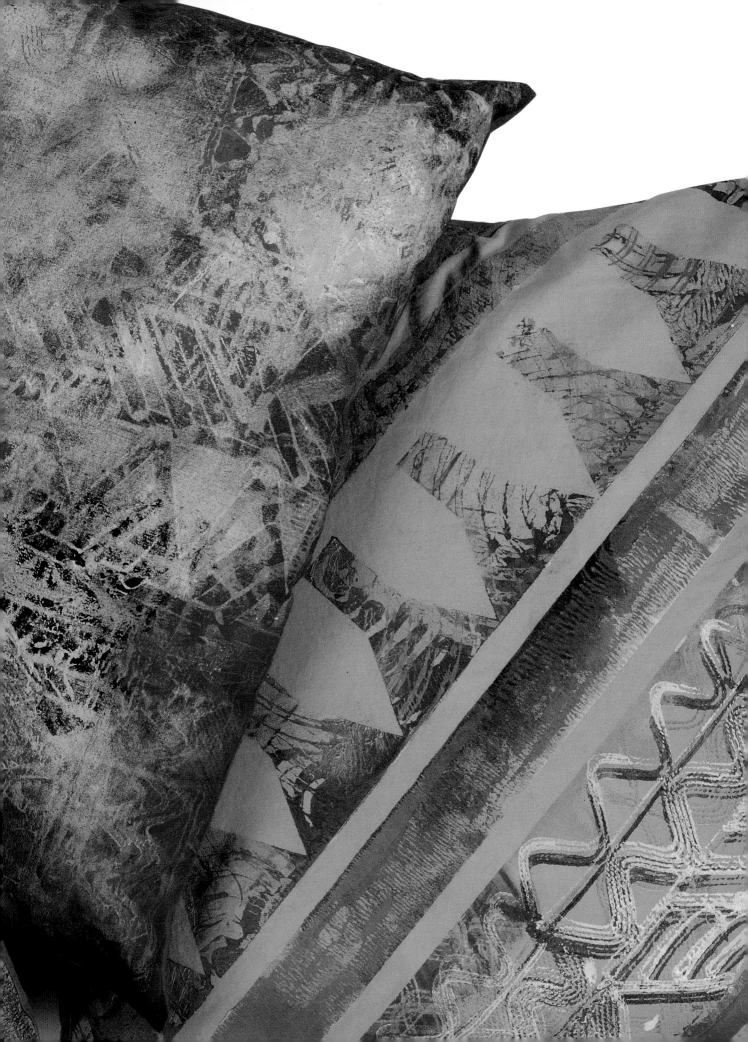

COMBINED TECHNIQUES WITH MARKAL, GLASS-PLATE PRINTING, BRONZE POWDERS AND ACRYLICS

This piece of fabric was made by gradually building it up through a series of techniques, including glass-plate printing, Markal, and printing with bronze powders and acrylics. The original fabric was immersion-dyed with navy Procion.

Before beginning this project, you will need to plan and prepare a design. The print illustrated is a series of oriental-type ogee shapes, which have been placed together to create a picture with interesting voided areas between them. Try sketching design ideas on a sheet of paper. Mark the design with areas that need to be kept unprinted and work out how the stencil will need to be cut to allow some areas to be masked. Plan the areas of the print, allocating areas for block printing, glass-plate printing and the use of Markal. Once the printing has begun, be prepared for your plans to change in response to the unique effects of the mediums and the fact that the different printing techniques will often give unexpected results.

Materials

40 cm (16 in) square padded surface
sticky-backed plastic (Fablon)
masking tape
craft knife, palette knife and round-bladed knife
10 cm (4 in) square printing block (see page 72)
acrylic colour (naphthol crimson, iridescent tinting medium, real teal, interference gold)
bronze powder (light gold)
metallic fabric medium (Ormaline)
two glass plates
Markal Paintstiks (iridescent turquoise, naphthol crimson, gold)
toothbrushes (one for each colour)
plastic tile grouter
Mask

Method

1 Prepare the fabric by taping it to the board or attaching it to a padded surface.

2 Mark the finished size with masking tape, in this case a 36 cm (14 in) square.

3 Draw the outline of your design onto the back of the sticky-backed plastic. Then use a craft knife to cut out the shapes for the design, taking care to mark which shape will be used as a frame and which will be used as a mask. It is worth keeping the pieces not used for this first print as they may be useful for later prints. Position the mask on the fabric, as described on page 80.

4 Remove the backing from the sticky-backed plastic at one corner and attach the mask to one corner of the fabric. Gently remove the backing and gradually press the mask onto the fabric. Any areas of the mask which are not quite accurate can be masked with masking tape, and small areas can have extra masks added.

5 Place a small amount of naphthol crimson acrylic onto one of the glass plates, and spread this across the whole plate with the roller to gain an even coating.

6 Using a paintbrush or a tile grouter, draw a diagonal grid into the wet acrylic, to look like trelliswork.

7 Print this pattern in the top right-hand corner of your fabric, taking care to temporarily mask any area beyond your design shape.

8 While this area of the print is drying, take a printing block and apply naphthol crimson acrylic. Print in the bottom left-hand corner of your fabric.

9 Use the roller to apply more naphthol crimson acrylic directly onto the fabric, colouring the two areas in the centre at the bottom. This will give a background colour to which further colour will be added later.

Previous spread: three African cushions using patterns developed from drawings made of African pots and patterns found on African houses. The cushion fabrics have been dyed in Procion dye, then printed with acrylic colour using block printing, glass-plate printing and rollering. The printing has been further enhanced by the addition of professional Markal Paintstiks, which have been applied adjacent to, and on top of, the prints as well as by rubbing over a block.

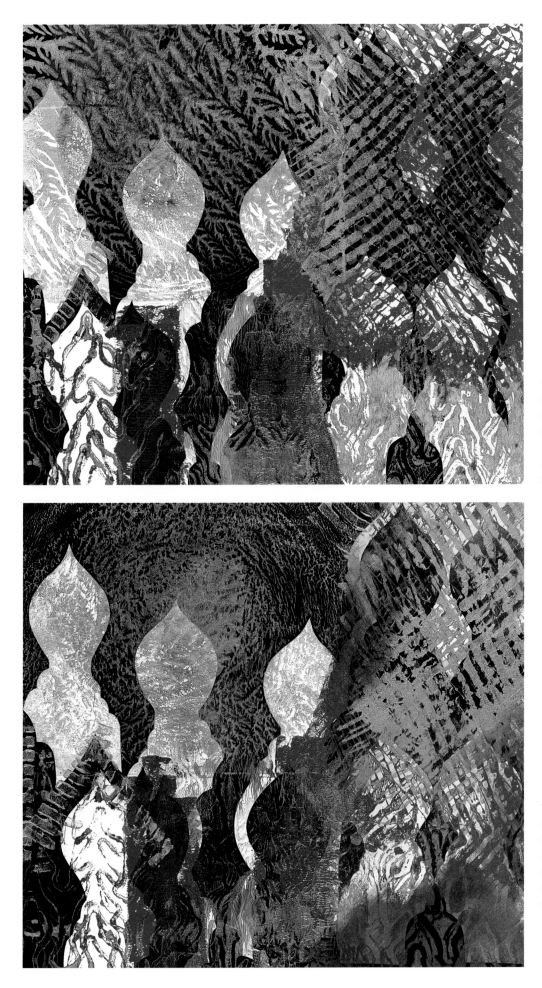

Viscose satin dyed with navy Procion dyes and then masked with sticky-backed plastic. Some areas have been printed with bronze powders and acrylic colours mixed with iridescent tinting medium.

The second stage of a combination print: Markal Paintstik has been applied to unprinted areas of the fabric, and over areas that have already been printed, altering the colour of the original print.

10 Add some interference gold to the remaining naphthol crimson, mix together, and roll the resulting colour across the plate. Draw into the colour to create a trellis pattern as before, and print again, slightly off-setting it from the earlier print.

11 Leave the print to dry and clean the glass plates and roller.

12 Take two clean glass plates and apply equal quantities of real teal acrylic and iridescent tinting medium. Put the two plates together and turn one of them 90 degrees. Separate the plates using a round-bladed knife and print the glass plate across the top left-hand portion of the fabric.

13 Add a little interference gold to the plate, press the two plates together, turn one of them 90 degrees, separate and print again on top of the previous print, being aware of how the second print relates to the first one.

14 Wearing a mask, add some metallic fabric medium to the acrylic colour and a small amount of the light gold bronze powder. Mix well and apply this mixture to the printing block.

15 Print the block over the previous naphthol crimson block print.

16 Carefully run the roller over the block until the pattern is transferred to the roller.

17 Carefully and gently print this pattern onto the fabric along the bottom, letting the pattern fill in areas that have not been coloured.

18 Finally, use a tile grouter to apply small areas of this mixture directly onto the fabric, creating further checks and marks to complement the grids printed earlier. The first photograph on page 105 shows the print at this stage with the sticky-backed plastic masks still in position.

19 The next stage is to use the Paintstiks on top of the prints and onto certain areas of the fabric. Ensure the prints are dry for this. First take the naphthol crimson, rub it generously onto the mask at the bottom right-hand side of the print, and brush the colour from the mask over the print and the dyed fabric with a toothbrush. It may seem that the fabric is not changing colour, but on carefully lifting the corner of the mask the difference will be easily seen.

20 Repeat this process with the gold and the iridescent turquoise Paintstiks, working across all the edges of the mask and working the colour onto the prints until you consider that the fabric has taken on a unity of style and colour. The second photograph on page 105 shows the nearly completed fabric with the masks still in place. It is easy to see where the Markal Paintstiks have been worked from the sticky-backed plastic onto the fabric as it has stained the plastic.

21 Leave the Paintstik colours to be absorbed. When dry, the surface should not seem oily – check that the colour cannot be smudged. This will probably take 48 hours.

22 Remove the masks carefully, checking that the areas of print and Markal are well defined. The photograph on page 107 shows the completed print with all the masks removed.

23 The print is now complete. If laundering is required the print will have to be ironed for at least four minutes. Iron on the wrong side as the areas of acrylic and bronze powders sometimes make ironing difficult.

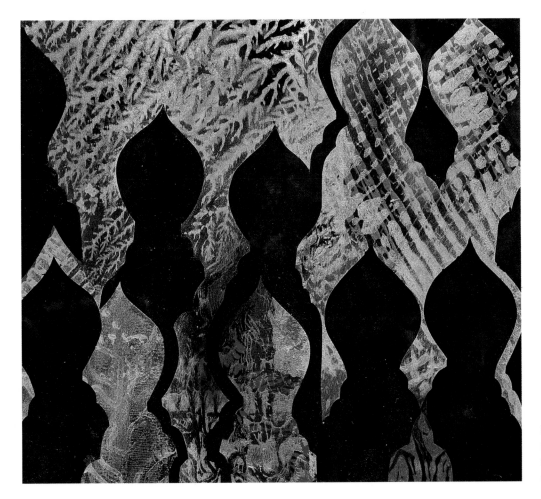

Fabric completed showing the masks removed and the subtle effects achieved by using these combination techniques.

USING PRINTED FABRICS TO CREATE A PIECE OF MACHINE APPLIQUÉ

This piece was made using a selection of printed and dyed fabrics, all coloured using methods described in previous chapters. The fabrics have been simply bonded onto a background fabric and machine appliquéd using a variety of machine embroidery threads to add interest.

Materials

a piece of calico and a piece of background fabric, cut on the the straight of the fabric, preferably plain in colour, with a flat, smooth surface. (The piece illustrated was approx. 40 cm by 30 cm (15¾ in x 11⅞ in). These two fabrics should be tacked together to give a stable background for the appliqué.)

a simple shape, drawn and cut out as a template, on light card

soft pencil

a selection of printed and dyed fabrics

Bondaweb or dressmaking web, to heat-bond fabrics together

sharp scissors with fine points (to trim to shape accurately)

iron and ironing board

sewing machine

machine embroidery threads

Method

1 Draw out the selected shape onto the light card, and cut it out to form a template.

2 Take a piece of Bondaweb; lay it on a surface with the backing paper facing up. Use the pencil to draw the shape onto the backing paper, but leave a margin between your line and the template. Repeat this process until you have sufficient shapes to complete your design. Even though the shapes will be ironed onto the reverse of the printed fabric, draw the shapes as they are to be used: don't worry about reversing the image.

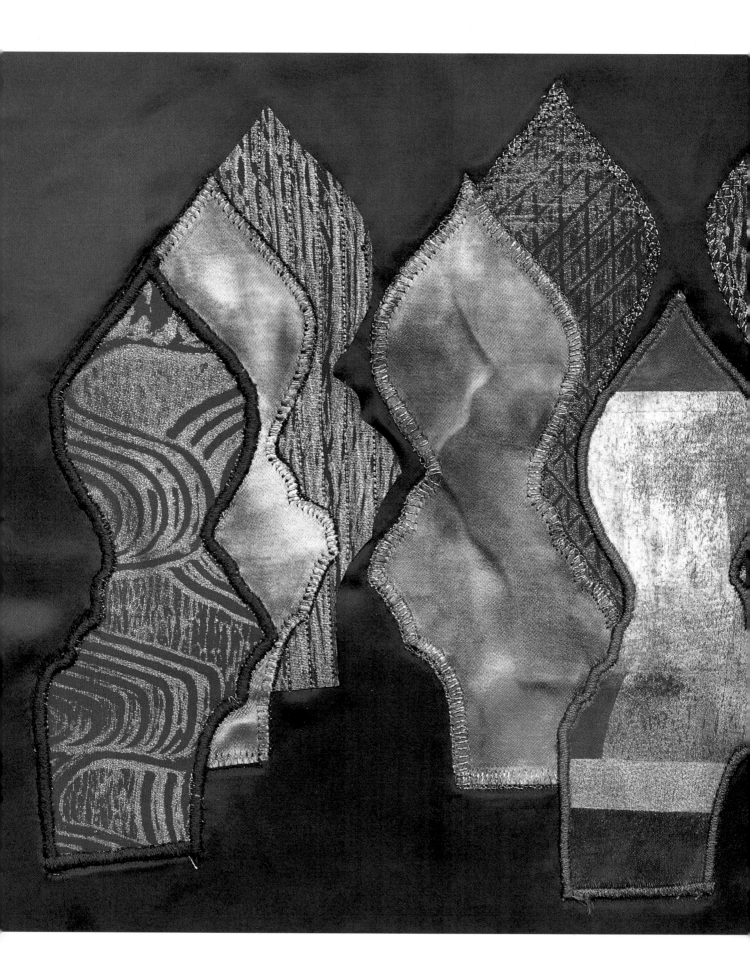

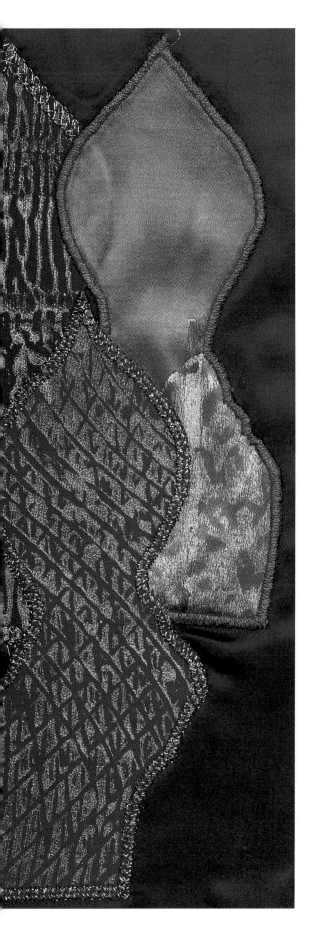

3 Cut one shape out of the Bondaweb, leaving a margin around each shape. (Cut out one shape at a time: Bondaweb tends to separate easily from its backing.)

4 Select the area of fabric to be used, and cut out a piece slightly larger than the shape. Lay the fabric right side down on the ironing board. Place the Bondaweb shapes on the wrong side of the fabric, with the paper next to the iron. Bond the Bondaweb to the reverse side of the fabric using a hot iron, taking care not to get the Bondaweb on the iron or on the ironing board.

5 Trim the paper, Bondaweb and fabric to the exact shape of the original template. Remove the backing paper, and place the piece right side up onto the background fabric. Pin this piece into position.

6 Repeat this process of selecting printed and dyed fabric, bonding, trimming and pinning until the composition is complete.

7 Once you are satisfied with the composition, tack all the pieces onto the background. Carefully iron the cut sections on the background fabric so that they are anchored into position.

8 Select a matching thread and, using a straight stitch, carefully machine around the edges of all the pieces, starting with the partially covered ones. Remove the tacking from these pieces.

9 Secure with machine satin stitch or decorative machine patterns, making sure to cover any raw edges. Repeat this process, starting with the pieces which are partially covered and then working on those in the foreground.

10 Finally, press again and trim any extra threads. The appliqué is then ready to be used to make a garment or for interior decoration.

Pieces of painted, dyed, printed fabrics which have been made using acrylic and bronze powders. The fabrics were cut using a template, bonded to the background fabric and then applied using various machine embroidery stitches.

LIST OF SUPPLIERS

Arjo Wiggins Fine Papers Ltd
Cateway House
PO Box 88
Basingstoke
Hants RG21 4EE
Tel: 01256 723000
(Manufacturers of paper in a
wide range of different qualities
and finishes.)

Art Van Go
16 Hollybush Lane
Datchworth
Knebworth
Herts SG3 6RE
Tel: 01438 814946
(A mobile art van, with mail order
service, supplying a wide range of
papers, bronze powders, acrylics,
dyes, Markal Paintstiks, acrylic
wax, etc.)

Colourcraft Ltd
Unit 5
555 Carlisle Street East
Sheffield S4 8DT
Tel: 0114 242 1431
(Brusho inks and Dytek dyes
by mail order.)

Daler Rowney Ltd
P.O. Box 10
Bracknell
Berks RG12 8ST
Tel: 01344 424621
(A wide range of artist's
materials. including acrylics
and inks.)

Liquitex Acrylics
COLART Craft Network
Whitefriars Avenue
Harrow
Middlesex HA3 5RH
Tel: 0181 427 4343
(A wide range of acrylic
colours, mediums and gels.
Excellent literature on
acrylic products.)

C. Roberson & Co. Ltd
1a Hercules Street
London N7 6AT
Tel: 0171 272 0567
(Full range of bronze
powders and
metallic mediums.)

Tomas Seth & Co.
Holly House
Castle Hill
Hartley
Kent DA3 7BH
Tel: 01474 705077
email: postmaster@tomas-
seth.com.uk
http://www.tomas-seth.com.uk
(Chromacryl, acrylic colours and
acrylic mediums.)

Whaleys (Bradford) Ltd
Harris Court
Great Horton
Bradford
West Yorkshire BD7 4EQ
Tel: 01274 576718
(Mail order, mainly plain, undyed
fabrics suitable for printing and
dyeing.)

**The World of Embroidery
magazine**
PO Box 42b
East Molesey
Surrey KT8 9BB
Tel: 0181 943 1229
(Bi-monthly magazine featuring
articles on textiles, embroidery
and design.)

Facing page: hand-painted
viscose satin embellished with
buttonhole stitchery using
various threads, including
some dyed with Procion.

INDEX